POSTCARD HISTORY SERIES

Early
Denver

ON THE FRONT COVER: This postcard shows the welcome arch at Union Station. Denver's welcome arch was erected at the entrance (east side) of Union Station at Sixteenth and Wynkoop Streets. Facing Sixteenth Street was the word "Mizpah," a Hebrew word meaning, "The Lord watch between me and thee when we are absent one from another." The arch was deemed a traffic hazard and was torn down in 1931.

ON THE BACK COVER: This c. 1920 view shows Champa Street at night, lit essentially the same way Larimer Square is today, with hundreds of electric bulbs strung high overhead and across the street. The May Company department store is on the far right, and the brightly lit Gas and Electric Building is near right center.

POSTCARD HISTORY SERIES

Early Denver

James Bretz

ARCADIA
PUBLISHING

Published by Arcadia Publishing
Charleston, South Carolina

Printed in the United States of America

Library of Congress Control Number: 2011929719

For all general information contact Arcadia Publishing at:
Telephone 843-853-2070
Fax 843-853-0044
E-mail sales@arcadiapublishing.com
For customer service and orders:
Toll-Free 1-888-313-2665

Visit us on the Internet at www.arcadiapublishing.com

To Sharon McIntyre, whose support made this book possible.

CONTENTS

Acknowledgments

I would like to thank the staff of the Denver Public Library Western History Department for their help in the researching of material for this book. Their expertise made the arduous task of scouring documents, papers, maps, and reams of microfilm much easier. Likewise, the staff of the Colorado Historical Society was very helpful in the gathering of information on Denver's early buildings, people, and events. Thanks to Rick Bass, Dorothy Bowie, and Ken Larsen for their continued support, as well as William Gard Meredith and David Ricciardi for their encouragement and for squiring me around town to visit the sites and former sites of buildings and events featured herein. Thanks to John and Henry Mulvihill for providing family information pertaining to John F. Campion. Nancy Casados, manager of DGEB Management, provided background information on the Gas and Electric Building, and Alan Gottlieb of the websites ustownviews.com and oldpostcards.com was helpful in the procurement of some of the historical postcards featured in this book. Thanks, also, to author and historian Tom Noel.

All postcards pictured herein are from the author's collection.

INTRODUCTION

Life would be no better than candlelight tinsel and daylight rubbish
if our spirits were not touched by what has been.

—George Eliot

Can the history of a town or city be accurately portrayed through a series of old postcards? The answer is both "yes" and "no." Postcards can and do reach back in time—but not too far. Although the first postcards were commercially produced in the 1860s, they did not come into general use until much later because of stringent government regulations in the United States. There were no graphics on the earliest cards. The first postcards with images were produced by the French in the 1870s and increased in popularity in the 1880s throughout Europe and eventually the United States.

US postmaster John Creswell introduced the first pre-stamped penny postcards in the early 1870s. But until 1898, the US Post Office was the only establishment permitted to produce postcards. In that year, Congress passed the Private Mailing Card Act, which allowed private publishers and printers to produce their own postcards.

Until March 1, 1907, postcards could not be printed with a divided back, and senders were only allowed to write on the front of the card. After that date, correspondents could write on the back left, with the right side reserved for the recipient's address. Consequently, it is generally difficult to find postcards (as we know them today) published before the first few years of the 20th century. From the 1860s to about 1900, we know what Denver looked like mostly through old photographs and prints. By 1907, Denver was well established as a hub of commerce and was not only a popular stopover for people traveling across America by train or wagon, but was also a destination for tourists who wanted to see for themselves the natural beauty of the Rocky Mountains.

Postcards, by their very nature, were meant to glorify and beautify. Flowery graphics and catchy phrases were the norm in the early days. Blissful images of fun seekers and adventurers adorned these cards, along with quaint and bucolic scenes of urban and rural life. Recipients were often lured to these spots, awestruck by what greeted them in their mailboxes. In the days before motion pictures and television, postcards were sometimes the only images people saw of places far away. Those living in farming areas were often introduced to the "big city" through these very illustrations. Postcards were sold through hotel and hospital gift shops, drug stores, train stations, and newsstands. Real-photo postcards were much more exact in their depictions of places and events, and the bulk of the images within this book are of this type. Consequently,

even though Denver was a well-established community by the turn of the century, this book covers the years from roughly 1900 to 1930 and doesn't address Denver's earliest years, from the 1860s through the 1890s.

Gold brought the first settlers to the area in the late 1850s, and camps were built along the confluence of Cherry Creek and the South Platte River in what is now lower downtown. The first prospectors were quickly followed by mining suppliers, who were followed in turn by other merchants, such as horse traders, wagon makers, saddle makers, clothiers, hardware suppliers, assayers, and real estate agents. The city grew steadily out from this center, and Denver became the temporary state capital in 1876 when Colorado was admitted to the Union. It became the permanent capital in 1881. In only a 20-year period, from 1870 to 1890, Denver's population exploded from around 5,000 to 100,000 people, becoming a thriving metropolis and one of the largest cities west of the Mississippi.

By the 1890s, suburbs, or bedroom communities, were being built around the edges of town, including Highlands to the west, Capitol Hill to the east, Curtis Park to the north, and the Baker neighborhood to the south. Fourteenth through Seventeenth Streets downtown became the center of shopping and finance. Colfax Avenue, which eventually became part of Interstate 40, still cuts a swath through the center of the city and has been called the "longest commercial street in America." Since downtown Denver was the center of town, postcards from the early 1900s offer an array of images of buildings and streets that were important to early Denverites. A vast number of the buildings featured within these pages are gone. Denver, like many other cities across the United States, suffered a bout of urban blight, mainly downtown, starting in the years of the Great Depression and lasting for decades. Downtown Denver was heavily residential in its early years, and it had many hotels, apartment buildings, and rooming houses sharing space with office buildings, restaurants, movie palaces, and retail shops. By the late 1950s, however, only the poorest and oldest residents remained. The advent of the automobile eventually made suburban living attractive and accessible to those who chose to move out of central Denver. New housing developments and apartment complexes were rapidly being built on the outskirts of town, pulling long-time residents away from the center. New shopping centers were springing up at the same time, making the downtown stores, which were once very popular and busy, a bit antiquated.

By the middle of the 20th century, many of Denver's aging buildings were fast becoming white elephants, too old to be useful and too expensive to overhaul. Residential buildings were abandoned and torn down. Old office buildings saw an increase in vacancies, and Urban Renewal, which was instituted in the late 1950s to address the problem of vacant buildings and urban blight, eventually steamrolled through downtown and the surrounding areas, essentially removing a great portion of the city's early heritage. The 1960s and 1970s were hit the hardest. Although many of the city's vintage buildings do remain standing, particularly in lower downtown and some of the surrounding neighborhoods, the images herein show us what Denver once was and, by comparison, what it is today.

One

THE STATE CAPITOL AND CIVIC CENTER

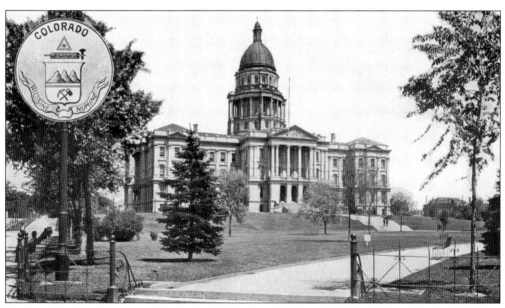

For decades after its construction in the 1890s, the gold-domed Colorado State Capitol Building seemed the center of Denver, with the rest of the city continually spreading outward in all directions. This photograph, taken in the early 1900s, shows the park-like layout to the west of the building, still evident today. Only the wire fencing is gone. Offices of Colorado's governor are located within its walls.

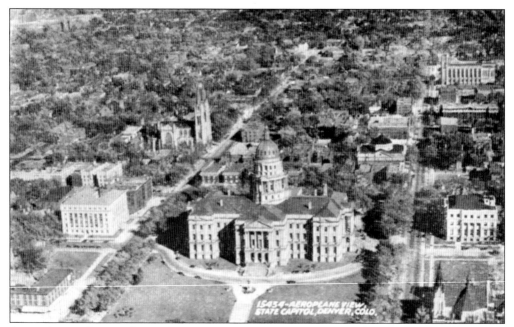

An early aerial view shows the state capitol building, bounded by Colfax and Fourteenth Avenues and Lincoln and Grant Streets. Directly left of the capitol building are the Colorado State Office Building and the Argonaut Hotel. Just beyond are the spires of the Cathedral of the Immaculate Conception at Colfax Avenue and Logan Street. To the immediate right of the capitol building is the State Museum.

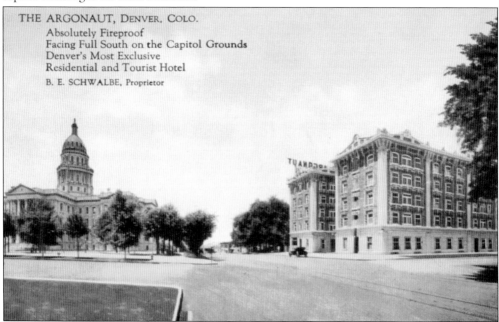

This postcard shows the Colorado State Capitol Building and the Argonaut Hotel. The hotel still stands at the corner of Colfax Avenue and Grant Street. In the early 1900s, the capitol building was surrounded by many hotels, apartments, and Victorian homes. The Argonaut Hotel replaced the turreted Victorian home of Albert Welch, an early Denver businessman.

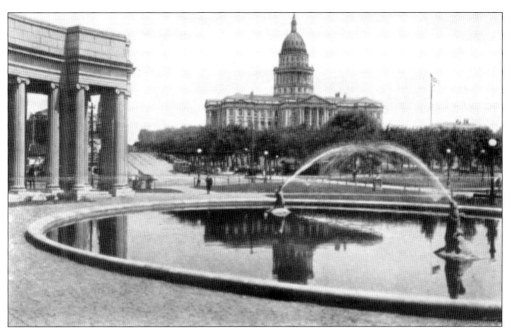

The Colorado State Capitol Building looms over Civic Center Park, which includes the Voorhies Memorial (left) and a reflecting pool with two spitting seals that was sculpted by Robert Garrison, who was also responsible for two bronze panthers guarding the entrance to the former Colorado State Office Building, a few blocks to the east at Colfax Avenue and Sherman Street.

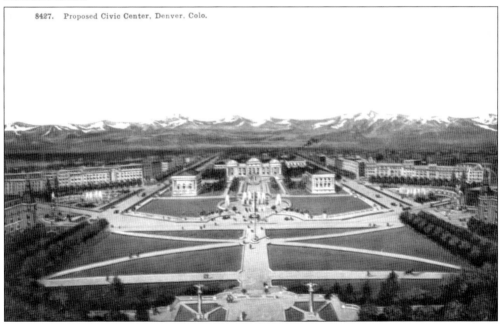

8427. Proposed Civic Center, Denver. Colo.

Plans for a civic-center complex were hatched during the administration of Mayor Robert Speer as part of his city beautification program. There were talks as early as 1904, but these plans did not become concrete for at least six more years. This postcard shows a proposal for the layout of the complex. This particular one never came to fruition.

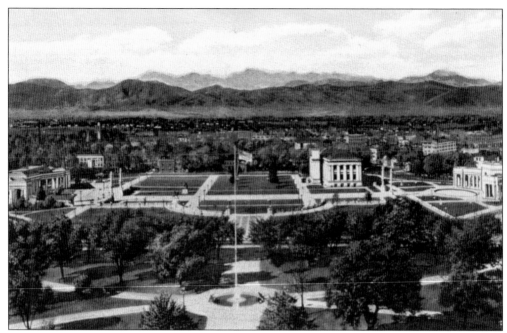

Once plans were agreed upon, it came time to clear two square blocks of existing buildings to make room for the park. In doing so, crews bulldozed scores of houses, apartments, and retail shops for an open-air plaza at the western slope of the state capitol grounds. The Carnegie Library, left center, was built on the north side of the park at 144 West Colfax Avenue and dedicated in 1910.

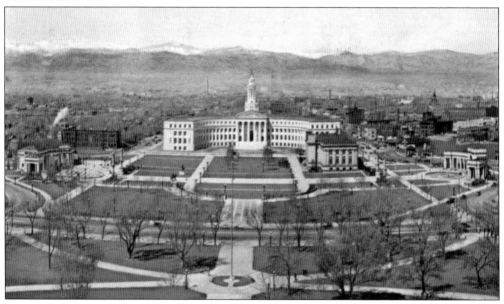

By the late 1920s, it became evident that the courthouse building at Sixteenth Street and Court Place was inadequate for the growing population. A new City and County Building was constructed just west of Civic Center in 1932 (pictured). More houses and apartments were removed to make way for the project, designed by the Allied Architects Association, a team of the city's most prominent architects.

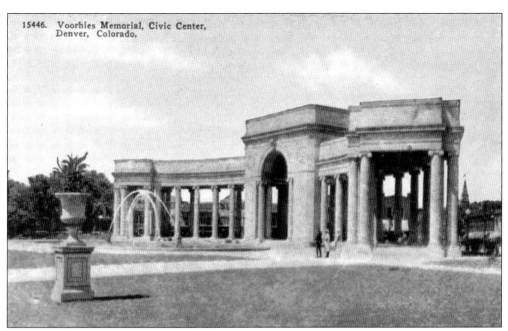

15446. Voorhies Memorial, Civic Center, Denver, Colorado.

When Civic Center was laid out, both the north (Fourteenth Street) and south (Thirteenth Street) ends were curved from their original straight pathways. The neoclassical Voorhies Memorial was constructed at the north end, shown here fronting a shallow pond with bronze sea lions spitting water high into the air.

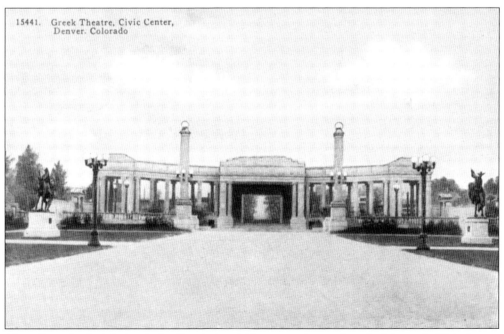

15441. Greek Theatre, Civic Center, Denver. Colorado

Also of neoclassical design is the Greek Amphitheater at the south end of the park. This theater has been used over the years for everything from musicales and concerts to lectures, temperance meetings, and political rallies. Adjacent is the Colonnade of Civic Benefactors, with names of early supporters of the Civic Center project engraved into the stone.

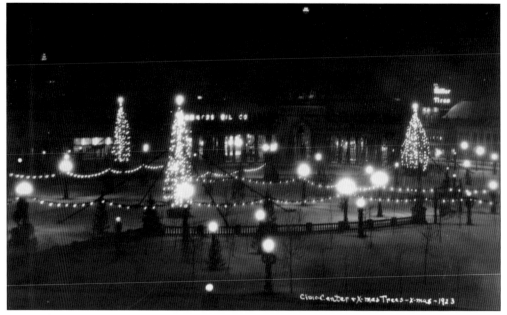

Denver began a tradition of decorating Civic Center for Christmas early on. Since this part of town was still a business and shopping hub, city fathers spared no expense in decking out the park for the holidays. This endeavor was eventually replaced by the now-famous lighting of the City and County Building, an annual event lasting from early December through the closing of the National Western Stock Show in January.

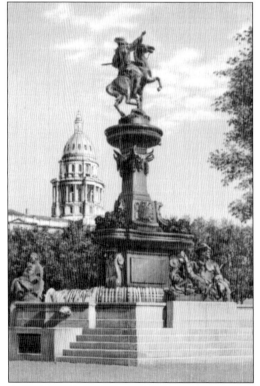

Denver's Pioneer Monument, near the Civic Center, was built in 1910 on a triangle of land at the corner of Colfax Avenue and Broadway. It replaced Engine Company Number One, downtown's early fire station. Designed by Frederick MacMonnies, this monument was dedicated in 1911 and marks the end of the Smoky Hill Trail. The monument and its fountain were restored in 1983 by the Park People and the City and County of Denver.

No. 3 Denver, Colo. Panoramic view of State Capitol from Fourteenth and Broadway.

This view looks northward from Fourteenth Avenue and Broadway. The capitol grounds are to the right. On the left and in the foreground is the former cable-car powerhouse, which is now part of Civic Center Park. The Majestic Building is seen behind it, and the Brown Palace Hotel is in the distance. The spire of the Central Presbyterian Church is near the center.

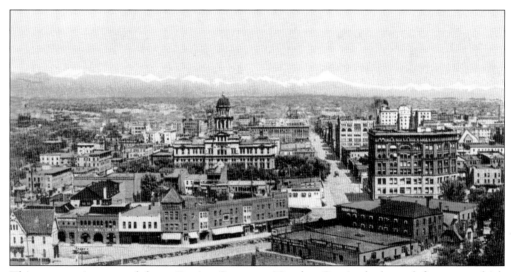

This panoramic postcard shows Engine Company Number One in the lower left corner, which was replaced by the Pioneer Monument. The Arapahoe County Court House (center), which was torn down in 1934, was replaced by a May D&F department store in the late 1950s. The two-tone Majestic Building is on the right. Most of the buildings in the foreground have been replaced by high-rise office towers.

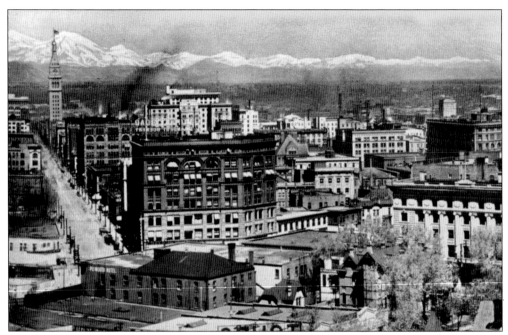

This view from about 1915 shows Sixteenth Street, left, from the top of the Colorado State Capitol Building, with the Daniels and Fisher tower in the distance. The Majestic Building is the two-tone building in the center, and on the right is the YMCA Building (white building with pillars). It is still in operation at that site.

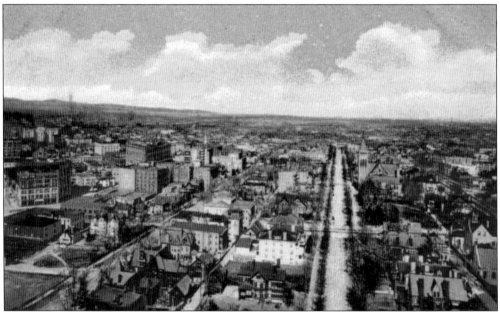

This view, looking north up Sherman Street from the dome of the Colorado State Capitol Building, shows the Majestic Building (left) at the entrance to Sixteenth Street, the Brown Palace Hotel, the spire of Trinity United Methodist Church just to the left of center, and some of the many Victorian mansions of north Capitol Hill. Central Presbyterian Church is on the upper right at 1660 Sherman Street. Colfax Avenue is just out of view on the bottom.

Two

DOWNTOWN

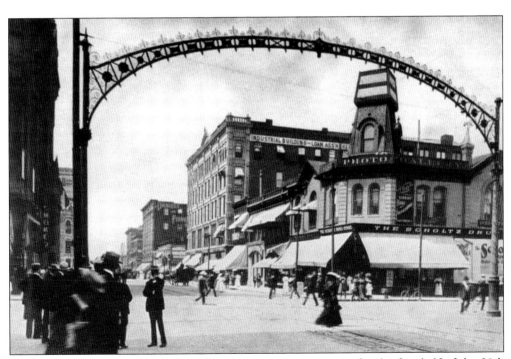

Downtown Denver was the hub of shopping and entertainment for the first half of the 20th century. Fifteenth and Sixteenth Streets, in particular, were heavy with foot traffic. This postcard shows the Scholtz Drug Company at the corner of Sixteenth and Curtis Streets. It was replaced with the American Theater building but continued to occupy the first floor of the new building. The site is now occupied by the Rock Bottom Brewery.

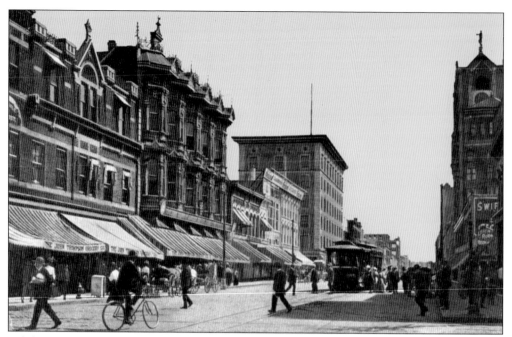

While Sixteenth Street was considered downtown Denver's major thoroughfare, Fifteenth Street, seen here, was its "little brother." There were, and still are, many retail shops and other businesses from Civic Center all the way west to lower downtown. Almost all of the buildings pictured here, including the Mining Exchange Building on the right, are gone.

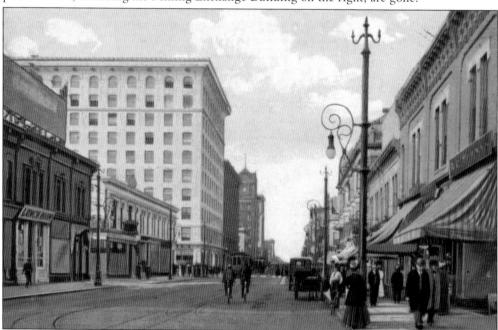

Looking west from Fifteenth and Stout Streets, this view shows the white Gas and Electric Building that replaced a two-story row of retail shops in 1910. The Mining Exchange Building is in the center; apparently, the artist decided a flagpole was easier to paint than the larger-than-life sculpture of a miner that actually graced the top of the structure.

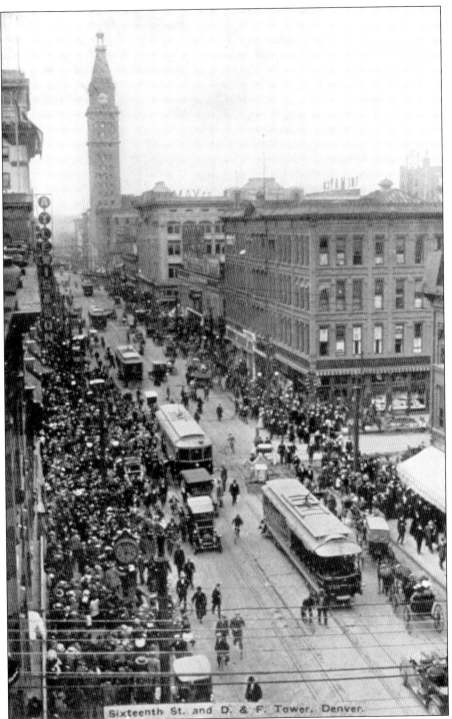

Sixteenth St. and D. & F. Tower, Denver.

Seen here along Sixteenth Street is the A.T. Lewis & Son Department Store (left), the Daniels and Fisher tower in the distance, the May Company building (center), and the Barth Block on the right at Sixteenth and Stout Streets. Note the streetcars with overhead lines and the horses and buggy alongside gas-powered automobiles.

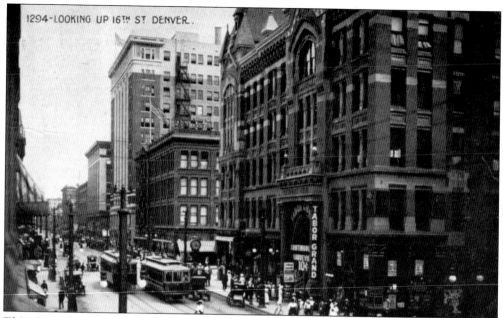

This view of a bustling Sixteenth Street, looking east, shows the Tabor Grand Opera House on the right at the corner of Sixteenth and Curtis Streets, the Joslin's Department Store building at center, and the tall A.C. Foster Building just beyond. A sign over the door of the opera house reads: "Continuous Vaudeville, 10¢."

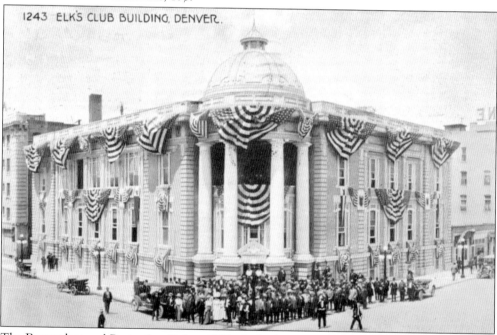

The Benevolent and Protective Order of Elks built their Lodge Number 17 at 1401 California Street in 1912. The building featured spacious meeting halls and stained-glass windows. This postcard, dated the same year, shows what is probably an inauguration event. The B.P.O.E. lodge was torn down in the 1970s when the Elks moved to a new building at 2475 West Twenty Sixth Avenue.

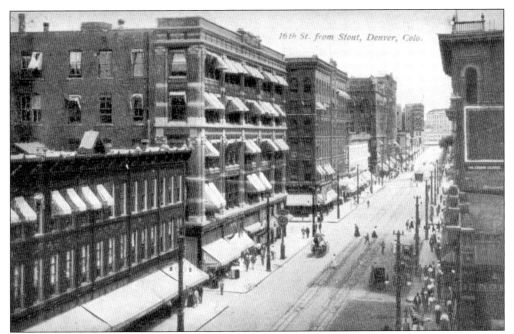

The Colorado Building (second from left) and the Mack Building (center) are shown here, looking eastward from Sixteenth and Stout Streets. Built in 1890, the Mack Building was designed by the Baerresen brothers, Harold and Viggio. They also designed the original St. Joseph's Hospital at Eighteenth Avenue and Franklin Street and the El Jebel Shrine Temple at 1770 Sherman Street.

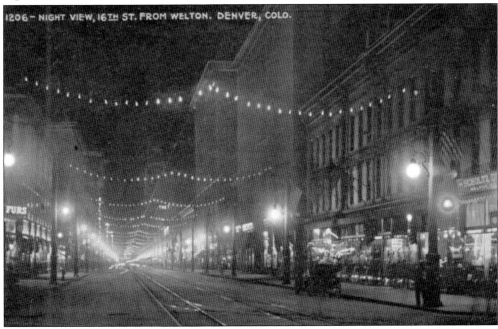

Shown here is Sixteenth Street from Welton Street. A branch of the Scholtz Drug Company is on the right. With the exception of weekends, downtown Denver literally closed down around 6 p.m. every night, after workers boarded their respective street cars to go home. It was not until the early 1990s when nighttime Denver began to come alive every night of the week.

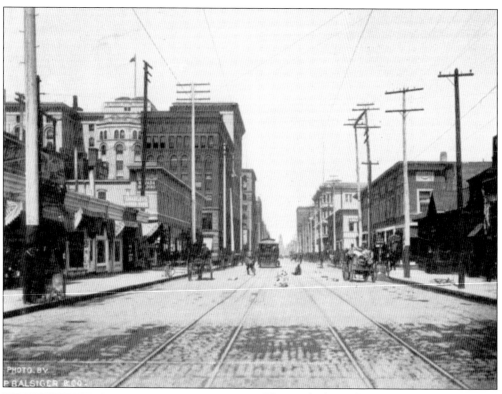

There is little evidence in this early view that Seventeenth Street was to eventually become central Denver's financial district. Among the institutions that were to be established along this stretch were the Denver National Bank, the United States National Bank, the Colorado National Bank, the Equitable (seen here at left) and Boston buildings (both centers of financial decision making), and the International Trust Company.

This postcard shows the Ideal Building (left) and the Boston Building (right) at Seventeenth and Champa Streets. These words are printed on the back of the card: "Denver has more than fulfilled the sanguine hopes of her founders. Some come with the expectation of finding a small and anything but metropolitan city. Few, indeed, expect to find the busy metropolis, the magnificent parks, and mammoth office buildings."

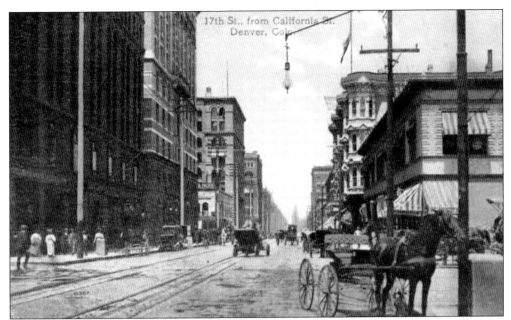

This view, looking west from Seventeenth and California Streets, shows the Albany Hotel with its original bay windows (on the right and in the center), the Equitable Building directly across the street from the Albany, and the Boston Building with its arched windows (center). Note the buggy with its tufted seat.

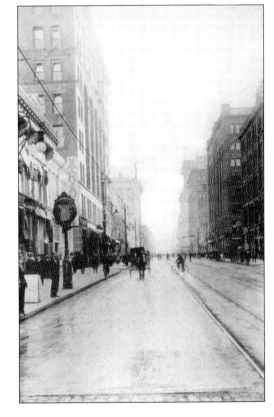

This postcard shows Seventeenth Street, looking east and toward the Ernest and Cranmer Building (second from the right) and the Boston Building (third from right). The tall Cooper Building is on the left, with the white Ideal Building in the distance on the right. Both the Boston and Ideal Buildings on Champa Street are still standing.

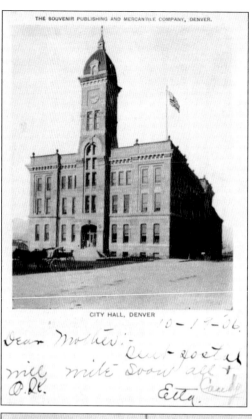

CITY HALL, DENVER

10 - 1 ?-06.

Dear Mother:-
Cut-post u
will write soon all &
O.K.
Etta.

The City Hall of Denver was located at Fourteenth and Larimer Streets and was erected in 1886. Municipal offices were located there, and many of the important decisions of the day were made within its walls. As the city grew, a number of its offices were moved in 1932 to the new City and County Building at Colfax Avenue and Bannock Street. The old Larimer Street building was demolished in the 1940s.

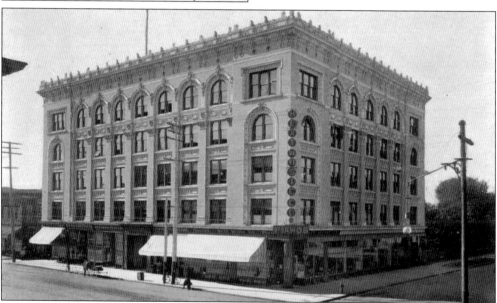

The Temple Court Building, designed by Frank Edbrooke and built in 1907 of steel and reinforced concrete, was equipped with its own power plant and artesian well. It was located at 630 Fifteenth Street. Temple Court, an office and retail building, was purchased in 1920 for $400,000 from then-governor Oliver Shoup and was sold again in 1923. The building was torn down a few years later.

Demolished in 1963, the Ernest and Cranmer Building was an office space located at 930 Seventeenth Street. It was built in 1891 by Finis Ernest and William H.H. Cranmer, who was the father of George Cranmer, civic leader and a one-time manager of the Department of Parks and Recreation. The left side of the reverse of the card states, "After March 1, 1907, this space can be used for a written message, using one-cent stamp."

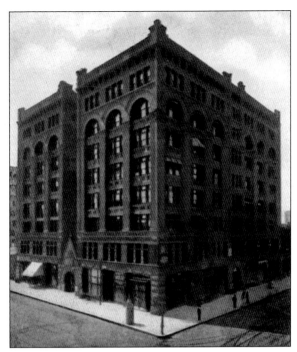

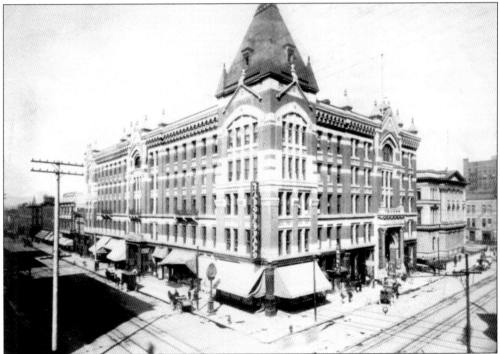

Horace Tabor made his millions in the silver mines of Leadville and elsewhere. After he divorced his first wife, Augusta, and married his mistress, Elizabeth "Baby Doe" McCourt, he spent his money lavishly, and the Tabor Grand Opera House was but one result. It stood at the southwest corner of Sixteenth and Curtis Streets. The site is now occupied by the Denver branch of the Federal Reserve Bank of Kansas City.

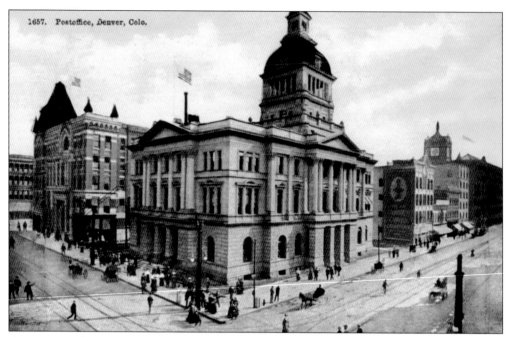

Construction began in the early 1880s on the Old Custom House, located at Sixteenth and Arapahoe Streets. It was once Denver's main post office, but it was inadequate from the start and the post office eventually moved to new quarters at Eighteenth and Stout Streets. The Arapahoe Street building later housed government agencies. It was torn down in the 1960s. The site is occupied today by the Federal Reserve Bank of Kansas City.

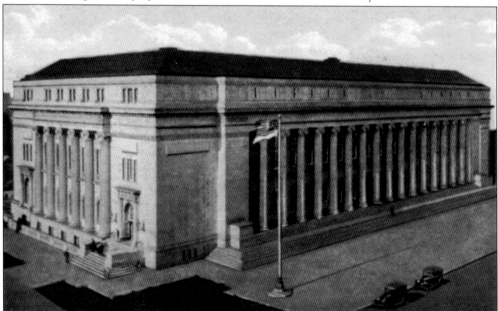

The post office's new Stout Street building was opened in 1916. According to the back of this card, it "cost $2,500,000 and is built of Colorado White Marble. It occupies an entire block in the business district and is claimed to be the most beautiful post office in the United States." This postcard was printed shortly after the building's construction.

The City Municipal Auditorium was completed in time for the 1908 Democratic National Convention, giving rise to Denver's role as a convention city. William Jennings Bryan was nominated as Democratic candidate for president but was defeated by William Howard Taft. The city hosted a second Democratic National Convention a century later, in 2008.

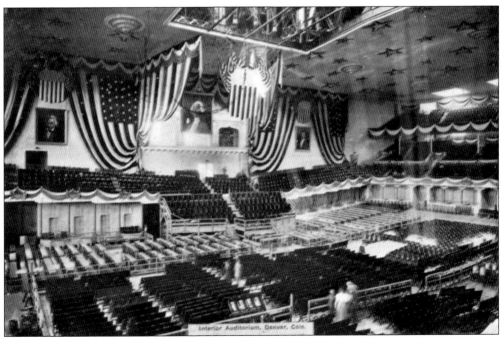

This image shows the Denver Municipal Auditorium, located at Fourteenth and Champa Streets, decked out for what is possibly the 1908 Democratic Convention. As president of the Denver Chamber of Commerce in 1900, Leadville mining magnate John Francis Campion had a hand in the planning of Denver's auditorium, as well as the planning of the Museum of Natural History in City Park.

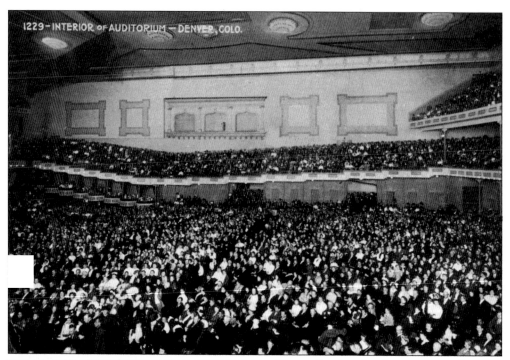

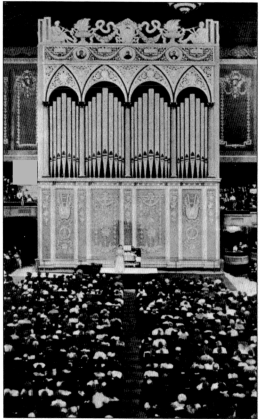

The auditorium has been extensively remodeled and is now part of the Denver Center for the Performing Arts complex, a cultural galleria, which includes the 2,225 seat Ellie Caulkins Opera House (the former auditorium building), Boettcher Concert Hall, and the Temple Hoyne Buell Theater.

The auditorium's giant Wurlitzer Opus 154–pipe organ was touted as "the world's largest pipe organ" when it was installed in 1918. According to an early newspaper account, "three hundred miles of wiring were used in the organ cables. The largest pipe is 32 feet high. The smallest is three-fourths of an inch." The organ was dismantled during a remodeling about two decades ago.

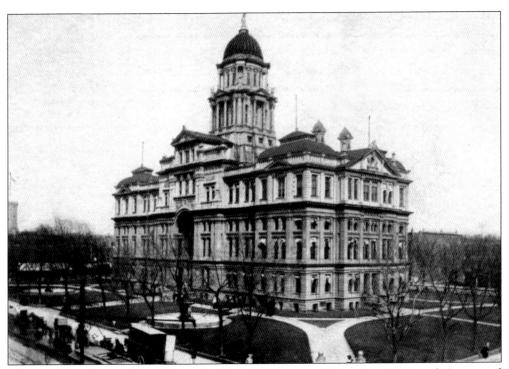

The Arapahoe County Court House, built in 1883 between Fifteenth and Sixteenth Streets and Court and Tremont Places, was a central fixture downtown until it was deemed outdated by city officials. It was replaced with a new City and County Building in 1932 at Colfax Avenue and Bannock Street.

Two large granite fountains flanked the entrance to the courthouse, which is pictured here. The courthouse building was torn down in 1934, and the site was then landscaped, creating a small park for area shoppers and office workers to enjoy. In the late 1950s, the land was purchased for the construction of a new May D&F department store, which was completed in 1958.

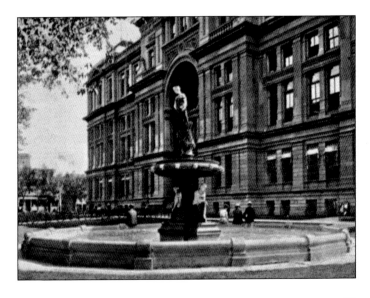

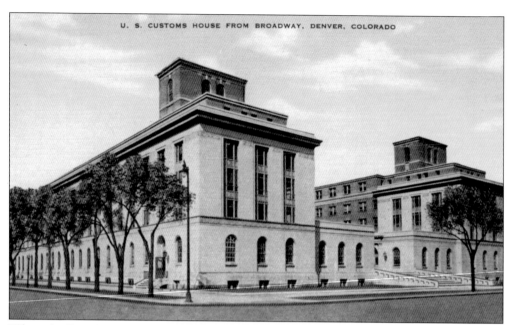

When the East Denver High School building, located at Nineteenth and California Streets, was vacated for new facilities at East Colfax Avenue and Detroit Street in the mid-1920s, the old building was used for administrative offices for a few years until it was demolished in 1929 to make way for the New Customs House (pictured), which was completed in 1931. It now mainly houses bankruptcy courts.

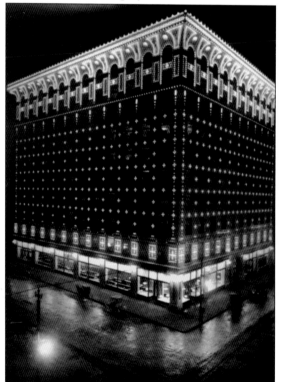

Faced with almost 7,000 light bulbs, the Gas and Electric Building has been a landmark at Fifteenth and Champa Streets since 1910. It was designed by Frank Edbrooke and was restored in the early 1990s as the Insurance Exchange Building. The building is again known as Denver Gas & Electric Building and since 1998 has been a carrier-neutral facility that hosts national and local carriers in the telecommunication industry.

The Mining Exchange Building was the first building in the United States devoted solely to the affairs of the mining industry and was a symbol of the money that helped lay the foundation of the city of Denver. Built in 1891 at 1030 Fifteenth Street, it was demolished in the early 1960s and replaced with the high-rise Brooks Towers, a retail/residential building.

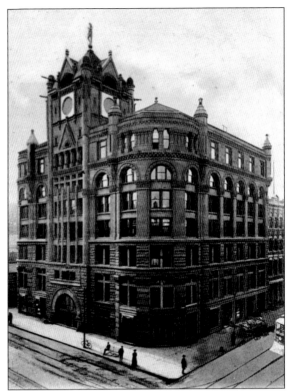

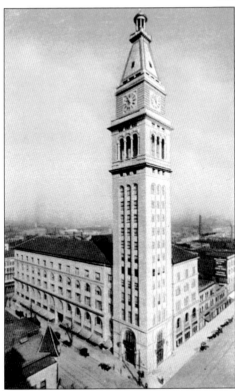

William Cooke Daniels and his partner William Fisher built their Daniels and Fisher department store at Sixteenth and Arapahoe Streets in 1911, which became a focal point for Denver shoppers for decades to come. Its tower was the tallest west of the Mississippi. The business was subsequently sold to the May Company, forming the May D&F department store. The tower still exists, but the store is gone.

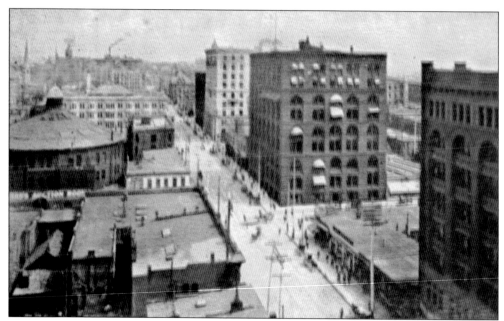

The round Gettysburg Building, constructed in 1885 at Seventeenth and Champa Streets, is seen on the left. It was built to house a giant cyclorama of the Battle of Gettysburg and was subsequently used as a post office. In the middle, with the arched windows and awnings, is the Boston Building. The Equitable Building is just beyond, with the Ernest and Cranmer Building on the right.

Another view of the Gettysburg Building shows the Albany Hotel directly behind it, and the dome of the State Capitol Building in the distance. The Gettysburg Building burned to the ground in 1905 and was replaced with the Ideal Building, the Chamber of Commerce Building, and the Buerger Brothers Building, all still standing.

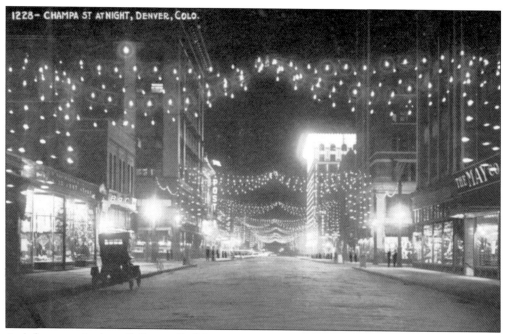

At left center is the tall Symes Building on the southeast corner of Sixteenth and Champa Streets, with the Denver Post Building directly behind it. The heavily lit Gas and Electric Building is at right center, and a branch of the May Company is on the right. This postcard is from approximately 1920.

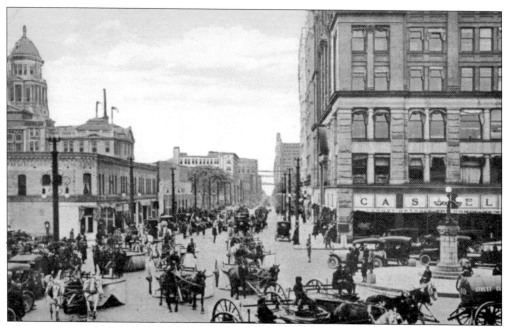

This scene shows the intersection of Broadway and Sixteenth Street looking west, with the Majestic Building in the foreground on the right and the Court House on the left. The Daniels and Fisher tower is in the center distance. Note the roundabout at right.

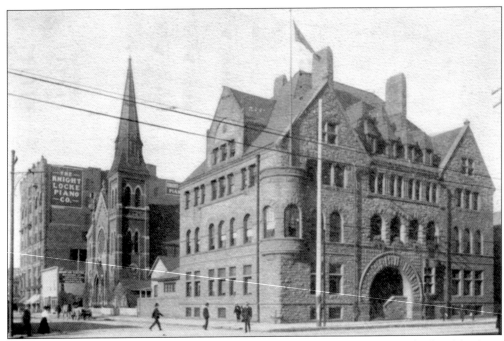

The Denver Club, located at 518 Seventeenth Street, was built as a retreat for local business and civic leaders. Erected in 1889, its members included railroad man David Moffat, Colorado governors James B. Grant and John Routt, and druggist-turned-entrepreneur Walter S. Cheesman. The Denver Club, a victim of dwindling membership, was replaced in 1954 by a high-rise tower called the Denver Club Building.

The Hayden, Dickinson, and Feldhauser building was erected at Sixteenth and California Streets in 1891 but was renamed the Colorado Building shortly thereafter. The original building still stands but is unrecognizable. In 1935, it was given a facelift, thanks to the talents of prominent local architect J.J. Benedict, who covered it with a shell of terra-cotta Art Deco detailing. It completed the look that is now familiar to passersby.

Located at 730 Seventeenth Street in the heart of what became Denver's financial district, the Equitable Building was completed with the Italian Renaissance Revival style in 1892 and was the most expensive and tallest building in Denver at that time. It contained the offices of many of Colorado's movers and shakers. The building has changed ownership a number of times and still stands.

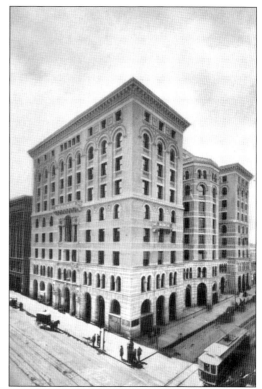

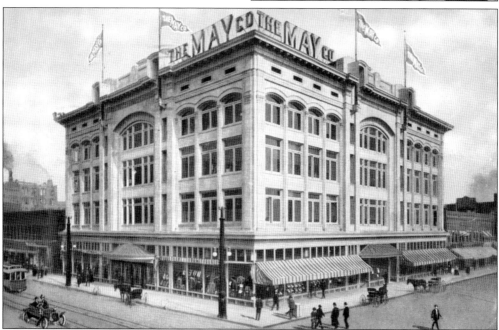

The May Company, located at Sixteenth and Champa Streets, was among a handful of major department stores downtown, including Daniels and Fisher, Joslin's, the Denver Dry Goods Company, the Golden Eagle, Neusteter's, J.C. Penney's, and A.T. Lewis, all located along Sixteenth Street. The May Company Building has been demolished.

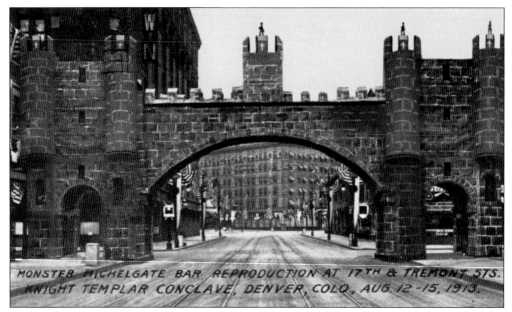

MONSTER MICHELGATE BAR REPRODUCTION AT 17TH & TREMONT STS. KNIGHT TEMPLAR CONCLAVE, DENVER, COLO, AUG. 12-15, 1913.

Varied organizations have held conventions and parades through downtown and packed the hotels and restaurants all over the city. One of the outstanding efforts, as far as expense and pure bedazzlement, was the Knight Templar Conclave of August 12–15, 1913. Shown here is the Monster Michelgate Bar reproduction erected at Seventeenth Street and Tremont Place, with the Brown Palace Hotel in the background at left.

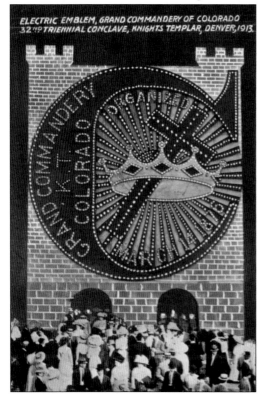

An "Electric Emblem, Grand Commandery of Colorado 32nd Triennial Conclave, Knights Templar," this structure was built downtown. The back of this postcard, mailed from Highlands Station, states, "This is outstanding and beautiful when the lights are turned on at night." Similar gates and entrances were constructed throughout downtown for the event.

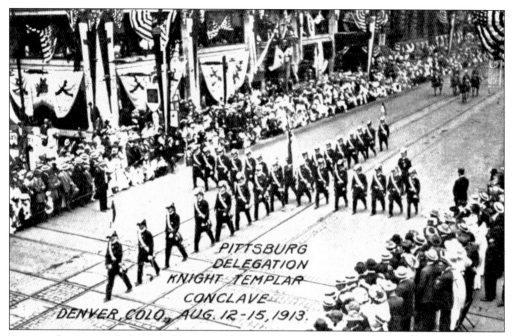

Among the events during the four-day convention was this parade along a heavily festooned Sixteenth Street. The Pittsburg Delegation is shown here. Written on the back of this card are the words, "This is the way the town looked when I came here. I wish we lived in Denver."

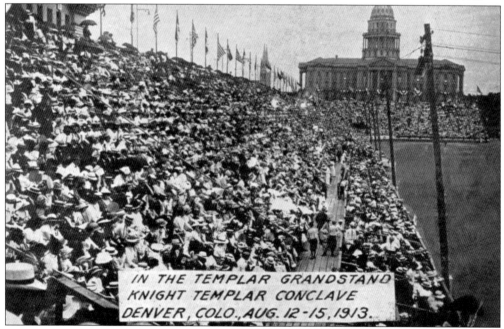

A specially built grandstand for viewing the proceedings was constructed at the north end of Civic Center, just west of the Colorado State Capitol Building. As evidenced by the large crowds gathered, this was probably a culmination of attractions and events, which brought throngs of Denverites from all points of the city. The crowd's size and the popularity of the event resemble today's annual People's Fair, which is held at the same location.

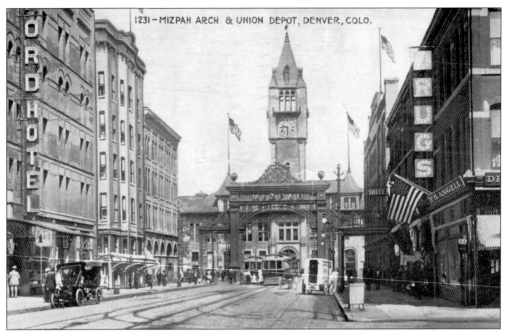

The city's first train station was built in the late 1860s to service the Denver Pacific Railway line. A decade later, there were four railroad stops in the city. One large central station was created by the Union Pacific Railroad to service all of these lines. Denver's Union Station, pictured here with its second clock tower, was built in 1880–1881 at Seventeenth and Wynkoop Streets. The Oxford Hotel is on the left.

Designed in the then-popular Italianate style by A. Taylor, with a steep roofline and narrow, vertical windows, the stone structure seemed impervious to disaster. But in 1894, a major fire swept through the station and destroyed the center section, including its original clock tower. This section was quickly replaced with a new tower, seen here in both photographs.

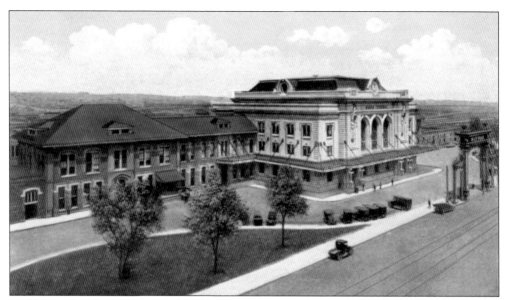

By 1914, rail traffic had increased to the point that the center section of Union Station had to be torn down and replaced with a larger section. The old wings remained in place, while the new section was constructed in the Beaux-Arts style and was designed by Denver architects Aaron Gove and Thomas Walsh. It was laid out with high-arched windows and a large open central area, which was surrounded by ticket offices and information booths.

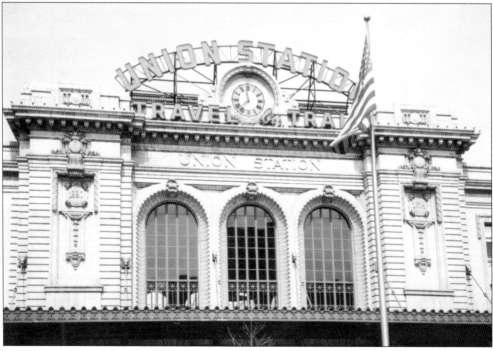

Passenger train travel has decreased over the years, mainly due to faster and more convenient air and highway travel. Union Station operates to this day, mostly to accommodate Amtrak and Denver's light rail system, but it sits in the midst of major development in the Platte Valley with a master plan to make it a major transportation hub.

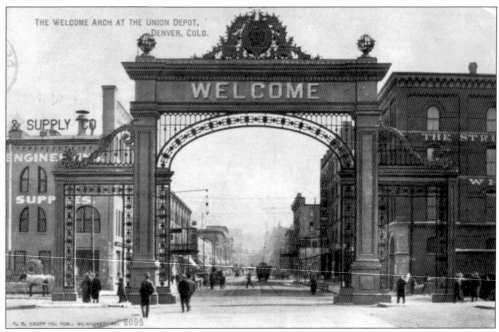

Union Station's welcome arch was positioned between the front of the station and the entrance to Seventeenth Street and was formally dedicated in 1906. Made mostly of iron, it was an impressive sight to those entering the city. "Welcome" was emblazoned across the side facing the station, while "Mizpah," a Hebrew parting phrase, was on the reverse. By 1931, the arch was deemed a traffic hazard and removed.

One of the city's handsomest structures was the Majestic Building, located at the east entrance to Sixteenth Street off Broadway. It was designed by Frank Edbrooke in the mid-1890s and was home to the Colorado State Bank from 1908 to the early 1970s. The Oxford-Anschutz Development Company razed the Majestic Building in 1977. A high-rise office building occupies the site today.

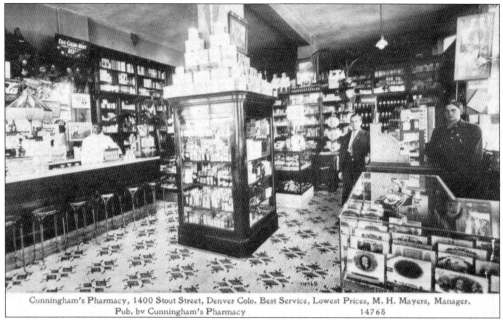

Cunningham's Pharmacy, 1400 Stout Street, Denver Colo. Best Service, Lowest Prices, M. H. Mayers, Manager.
Pub. bv Cunningham's Pharmacy 14768

Cunningham's Pharmacy, located at 1400 Stout Street, was typical of the many drug stores found throughout Denver during the early 1900s. Prescriptions were dispensed in the back of the store, cherry phosphates were handed out at the soda fountain, and dime novels were purchased from the magazine rack. Pharmacists often ran the entire store. Signs here include advertisements for Coca-Cola and an egg-cocoa-mint drink for 10¢.

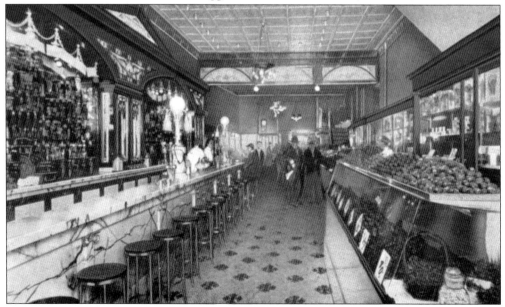

George Allison's candy store, the "leading confectionery in the West," was located at 1011 Fifteenth Street in about 1910. Note the polished marble soda fountain with its brass cash register, the stained-glass insets in the back-bar, and a ceramic-tile floor. The long, narrow space was characteristic of many of the retail outlets found throughout downtown Denver in the early 1900s.

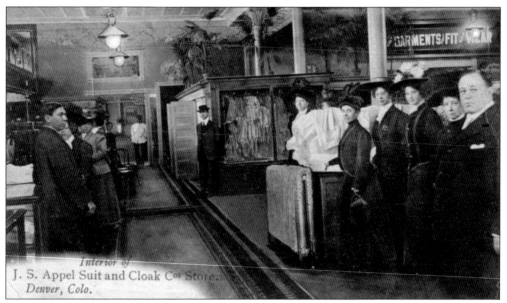

Interior of
J. S. Appel Suit and Cloak C⁰ˢ Store.
Denver, Colo.

Appel's Clothing Store was located in the Appel Building at 1230 Sixteenth Street, just west of the Golden Eagle Department Store and diagonal from the May Company building. Appel's was characteristic of the clothing and tailoring shops found throughout downtown, where women would shop for blouses and skirts for themselves, shirts and pants for their husbands, and knickers for the kiddies.

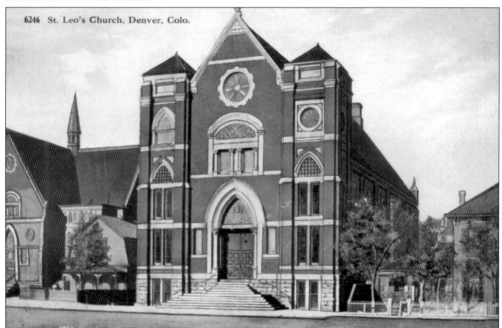

6246 St. Leo's Church, Denver, Colo.

St. Leo's was one of many Catholic churches built throughout downtown and the surrounding areas. It was constructed in 1891 at West Colfax Avenue and Tenth Street. Its members were mainly German and Polish immigrant families, who lived in the adjacent Auraria neighborhood. As the area expanded with commercial enterprises, these families moved out and membership dwindled. The church was torn down in 1965.

Three

PARKS

City Park in east Denver is bounded by Seventeenth and Twenty-third Avenues, York Street on the west, and Colorado Boulevard to the east. It offered an idyllic respite for Denver's citizens, especially during the hot summer months before the days of air conditioning. City Park's early amenities included soda, ice cream and popcorn stands, boating, fishing, and for a short time, train rides around the little Duck Lake.

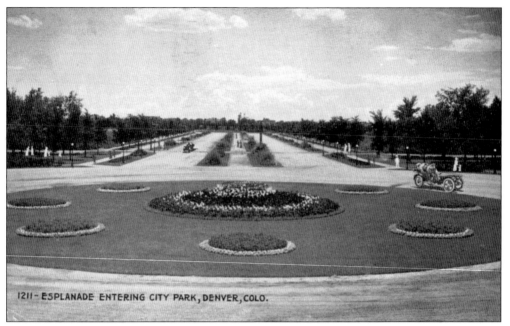

1211 - ESPLANADE ENTERING CITY PARK, DENVER, COLO.

The Esplanade was the main route connecting Colfax Avenue on the south to City Park on the north. The Colfax Avenue entrance consisted of a circular drive around a flowerbed, with landscaping designs changing almost every year. In 1918, the Joseph Addison Thatcher Memorial Fountain was installed at the north terminus (far end of this picture).

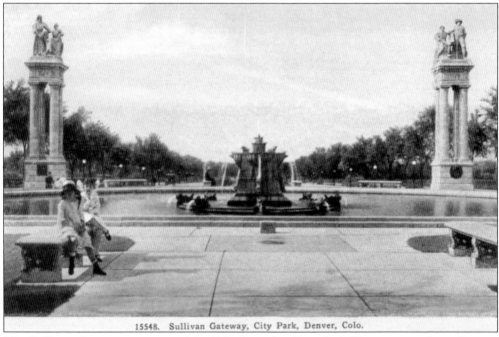

15548. Sullivan Gateway, City Park, Denver, Colo.

The Sullivan Gateway was erected in 1917, honoring Dennis Sullivan, a prominent Denver banker. The 40-foot pedestals hold sculptures depicting mining and agriculture and were created by sculptor Leo Lentelli. The Dolphin Fountain, in the foreground, replaced the original flowerbeds and is still in working condition.

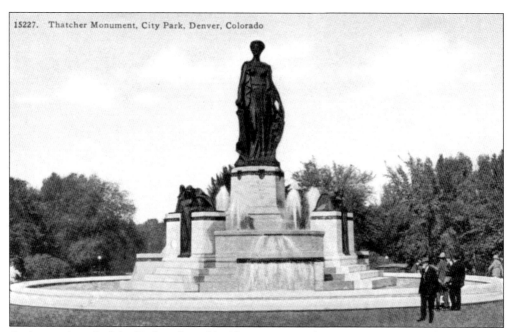

15227. Thatcher Monument, City Park, Denver, Colorado

At the north end of the Esplanade and inside a Seventeenth Avenue entrance to the park is the Joseph Addison Thatcher Memorial Fountain, named after a prominent Denver banker. It was made of granite and bronze and was presented to the city by Thatcher in 1918. Its powerful jets of water shoot high into the air and have long been a summertime attraction for local children.

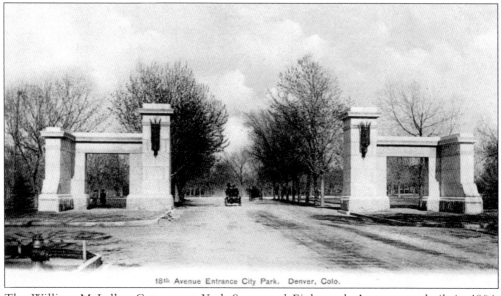

18th Avenue Entrance City Park. Denver, Colo.

The William McLellan Gateway at York Street and Eighteenth Avenue was built in 1904. McLellan was a city council member in the mid-1880s who rallied legislators to purchase the land for City Park. The gate was later closed and was moved north to York Street and Twenty-first Avenue in 1957.

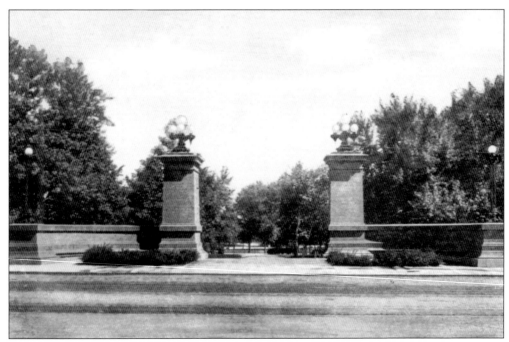

The red sandstone Richard Sopris Gateway was a gift to the city from Simpson T. Sopris in memory of his father, who was a Colorado pioneer, one-time city mayor, and the first park commissioner of Denver. Richard Sopris died in 1893 and is buried at Riverside Cemetery in north Denver. The gate was erected in 1912 near Seventeenth Avenue and Fillmore Street.

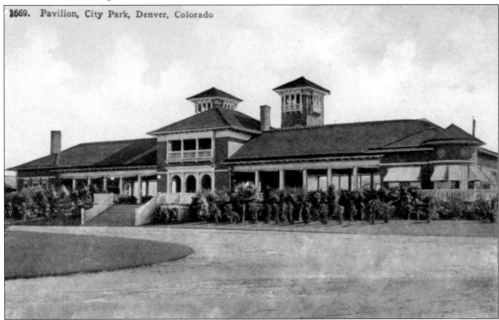

The first City Park pavilion was a small structure adjacent to the little lake, which was also called Duck Lake. A much larger pavilion, seen here, was erected near the west shore of the large lake. This pavilion has been remodeled a number of times over the years and now serves as a center for weddings, parties, fundraising events, and corporate picnics.

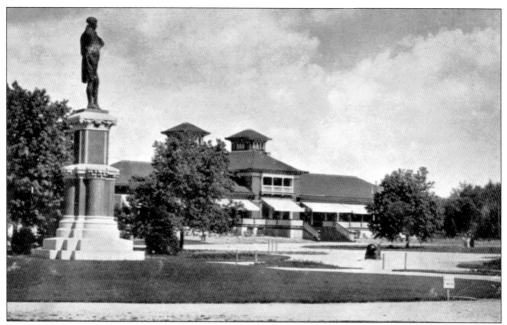

This postcard shows the pavilion with the Robert Burns statue in the foreground. This monument to Scotland's great poet stands in a garden just west of the pavilion. It is made of bronze with a granite base and was presented to the city by the Scots Caledonian Club of Colorado in 1904.

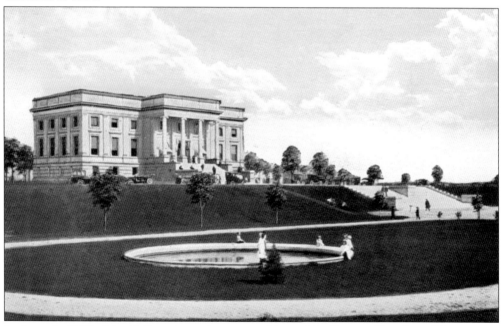

In the early 1900s, John F. Campion, who was president of the Denver Chamber of Commerce, and his cronies met to drum up support for a permanent natural history museum at the east end of City Park, located at Colorado and Montview Boulevards. It began with the acquisition of the taxidermy collection of naturalist Edwin Carter of Breckenridge. The museum, seen here, opened in 1908.

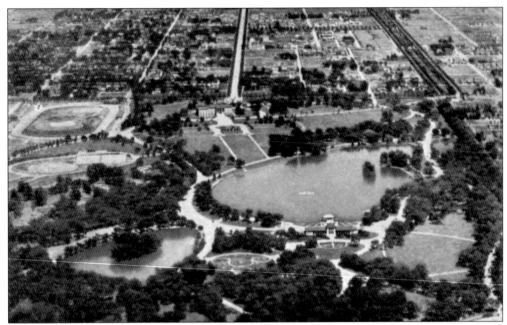

This aerial photograph shows the Duck Lake (small lake on the left) and the large lake at City Park, along with the pavilion (foreground) and the Museum of Natural History (top center). Montview Boulevard is just beyond the museum, with Seventeenth Avenue Parkway to the upper right.

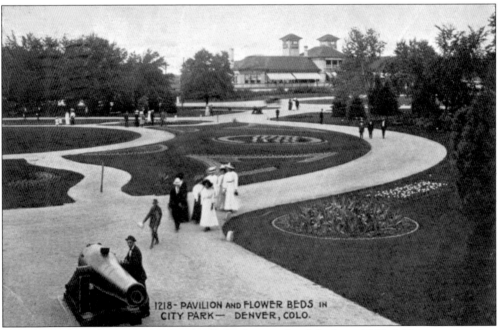

1218- PAVILION and FLOWER BEDS in CITY PARK— DENVER, COLO.

This idyllic scene shows the pavilion in the background and the beautifully laid out gardens just to the west of it. The cannon was among three large artillery pieces donated to the city by the Grand Army of the Republic and placed in a circle. They are all Civil War relics. The Robert Burns statue now stands in the center.

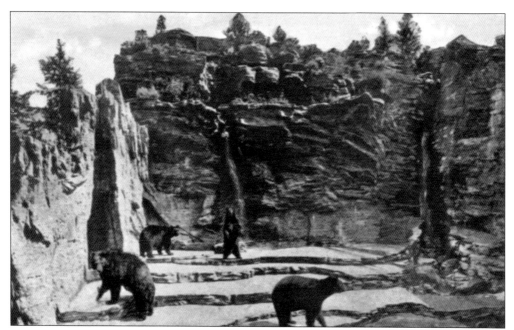

Among the popular features at the park's zoo were sculpted rock formations of concrete and wire, created to give the public a naturalistic display of the wildlife. The bear's habitat was built in 1918 and designed by zoo superintendent Victor Borcherdt.

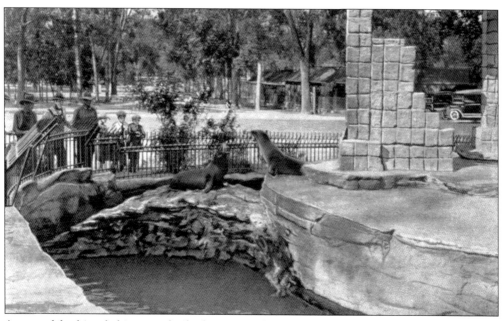

A natural–looking habitat was built about 1917 for polar bears and otters, which entertained visitors by swimming back and forth in the moat. The zoo began as a small affair but continually expanded over the years. Today, it is considered one of the finest in the country.

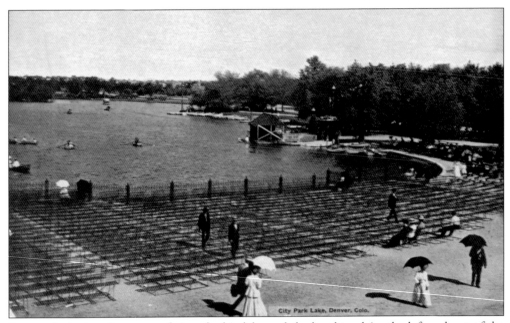

Rows of wire benches are set facing the big lake and the bandstand (to the left and out of the picture). A floating bandstand was built close to shore in the 1890s and has been replaced since then. Band concerts have been a popular summer activity for decades with few interruptions.

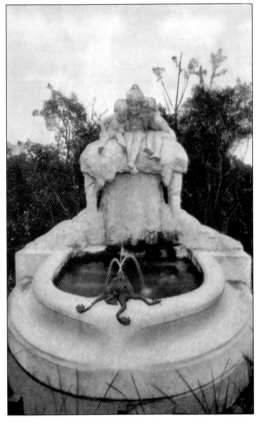

The Children's Fountain is a replica of a fountain in Dusseldorf, Germany, and was part of Mayor Robert Speer's city beautification program in the early 1900s, which included the paving of Speer Boulevard along Cherry Creek, the construction of Civic Center Park, and the expansion of the Denver Zoo.

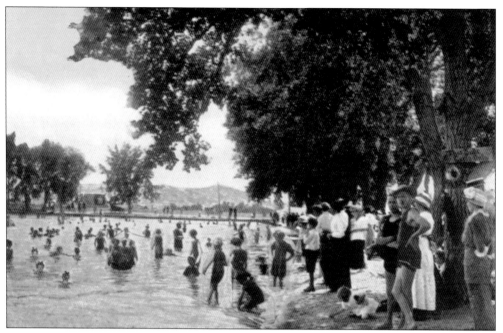

Washington Park has been in existence since 1891 and is bordered by East Virginia and Louisiana Avenues and South Downing and Franklin Streets. It has been a magnet for family gatherings, picnics, walking, jogging, and fishing from Washington Park Lake. Swimming was allowed in the early days, but strict dress codes had to be adhered to.

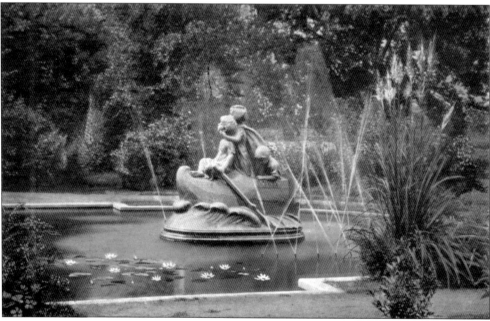

Inspired by the Eugene Field poem "Dutch Lullaby," sculptress Mable Torrey of Sterling, Colorado, created this statue in 1918 named Wynken, Blynken, and Nod, under the auspices of then-mayor Robert Speer. It was moved from its original location to its present site near Franklin Street and Exposition Avenue, where it continues to bring joy to park visitors.

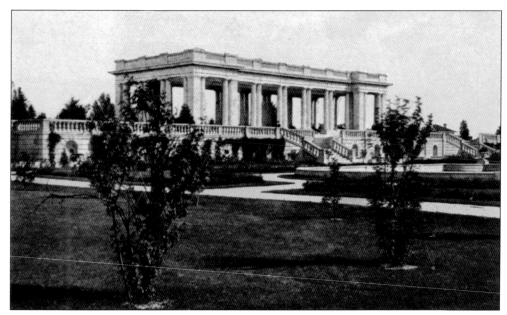

Walter Scott Cheesman, druggist-turned-entrepreneur, invested wisely in everything from utilities and railroads to banking and even Denver's water system. He became one of the city's wealthiest men but was also viewed as monopolistic and greedy. By the time he died in 1907, his name was "mud." His widow, Alice, paid for the construction of a marble pavilion in his namesake park, which was to partly appease the citizens of Denver.

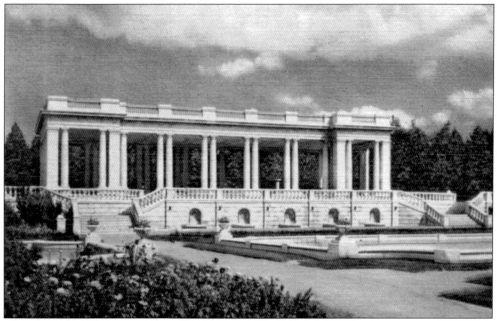

Originally, its west facade was designed with stairs, balustrades, and lion-head fountains. These have been bulldozed and covered over with a sloping lawn due to years of disrepair. There have been recent discussions about restoring this portion of the pavilion. Cheesman Park was one of the city's first cemeteries. Bodies were relocated as the park was laid out, but workmen still come across century-old remains.

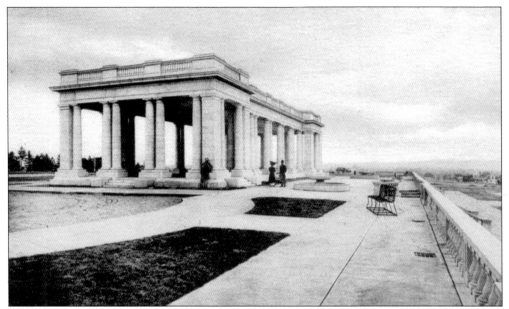

During the summer months, the west lawn of the pavilion was, during the 1950s, the site of the very popular Show Wagon, a cavalcade of local talent of mainly school children, which included singing, dancing, piano, trumpet, and accordion solos, along with skits and short reviews. The pavilion stands today as the centerpiece of the park.

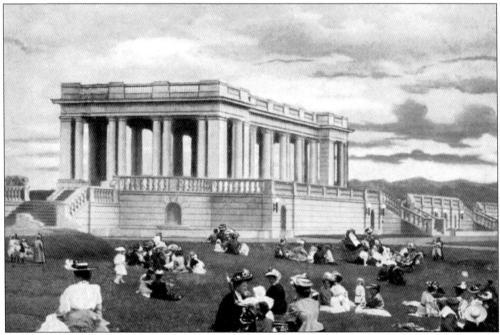

This view shows people gathered on the northwest lawn enjoying a summer sunset about 1915. The pavilion was used as a backdrop for the summertime *Denver Post* operas, presented from 1934 to 1972 under the auspices of Helen Bonfils, daughter of *Denver Post* co-owner Frederick Bonfils. "Miss Helen" was also an actress and a benefactor of the Elitch Theater in west Denver.

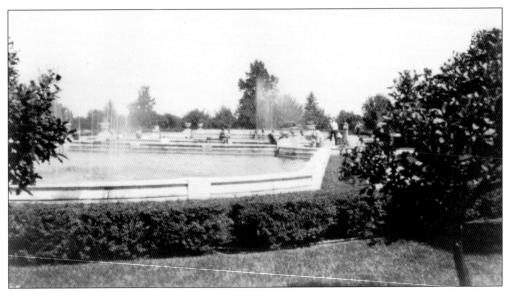

The shallow pools on the west front of the pavilion have always been a draw for neighborhood children during the hot summer months. They have been rebuilt a few times over the years, and this postcard depicts a different fountain system than is in existence today. Now there is but one high water jet in the center of both pools.

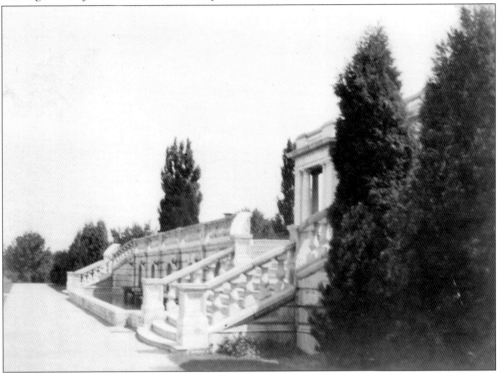

This postcard shows the graceful, sloping stairways that gave the pavilion a sense of grandeur during the early days. Over the years the pavilion fell into disrepair and was vandalized. A group known as the Park People adopted the structure, and the pavilion's renovation was one of their projects.

Four

HOTELS AND APARTMENTS

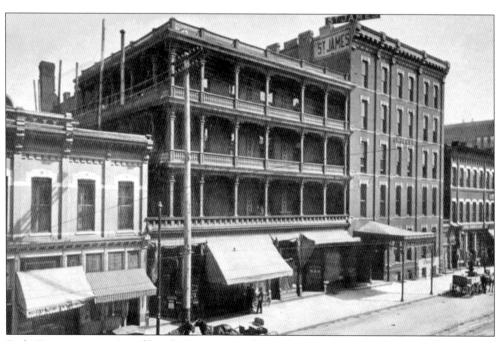

Early Denver was a city of hotels. It was unsettled and a stopping point between the east and west coasts. Downtown was filled with livery stables, hardware stores, and wagon and carriage makers—everything the traveler needed to make his way onward. The better hotels offered every convenience, including hot meals, indoor plumbing, and (in some cases) electric lighting! The St. James Hotel, located in the 1500 block of Curtis Street, was one such hotel.

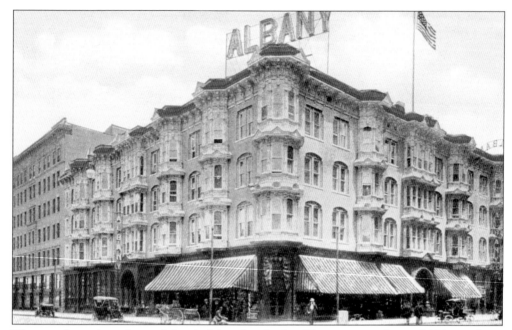

The grand opening of one of the city's best hotels, the Albany, attracted over 1,000 people on a hot July night in 1885. The architect was E.P. Brink, and the owner of the hotel was one W.H. Cox. He named his hotel at Seventeenth and Stout Streets in honor of his hometown of Albany, New York.

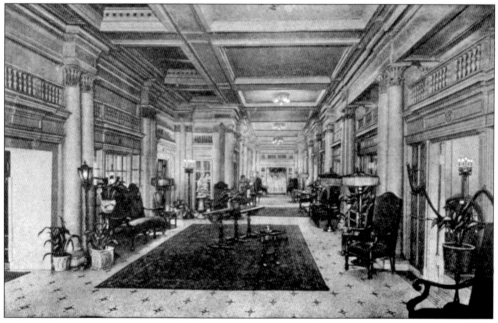

In its earliest years, there were 155 luxurious rooms, and the furniture was made of walnut, mahogany, and oak. Persian carpets were strewn everywhere throughout the rooms and vast hallways, which were all lit with electricity, an innovation for a Denver hotel at that time. The Grand Promenade is seen here.

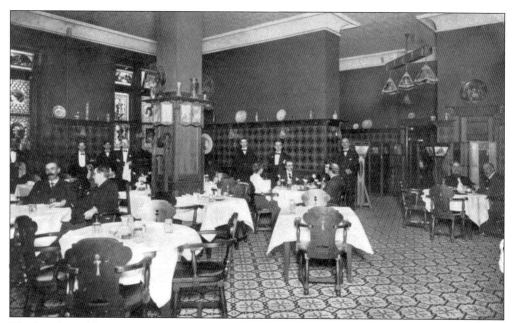

The hotel quickly gained a reputation as an elegant hostel in a dusty western town. One of the hotel's early dining rooms, the Bohemia, is seen here, and it is sparse by later hotel standards but fashionably decorated with crown molding and stained-glass windows. An alert wait staff attended to every patron's needs.

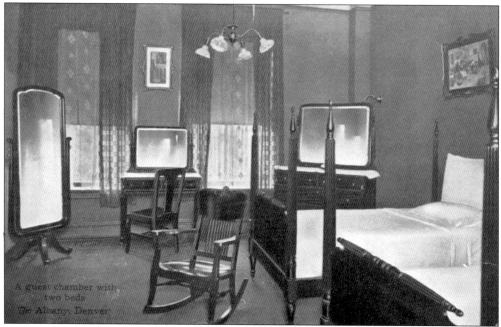

A guest chamber with two beds at the Albany, Denver

Every modern convenience could be found at the Albany, including steam heat, hot and cold running water, and room service. Most suites had private baths, and single rooms had bathrooms close by. The hotel's proximity to Denver's business and shopping core made it an ideal spot for travelers to unpack their suitcases.

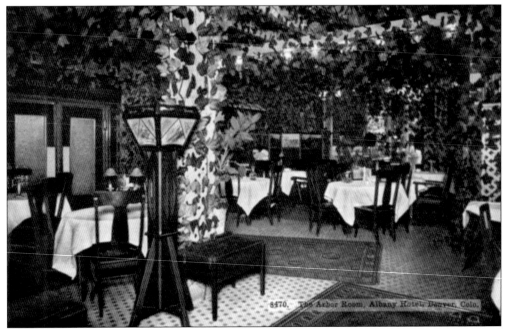

As the years progressed and the hotel gained in popularity, the interior took on a grander look and feel. Here is the Arbor Room, which was decorated with stained-glass lamps and paper greenery. The hotel was continuously redecorated over the years to keep up with changing tastes and trends.

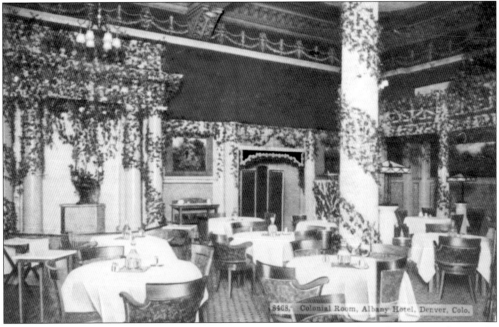

Eventually the hotel had a handful of different dining areas, each with its own theme. In 1914, the Colonial Room (pictured) offered Lobster Newburg for 75¢ or caviar for $1.25. Part of the hotel's appeal was its reasonable rates while at the same time offering its patrons luxurious surroundings.

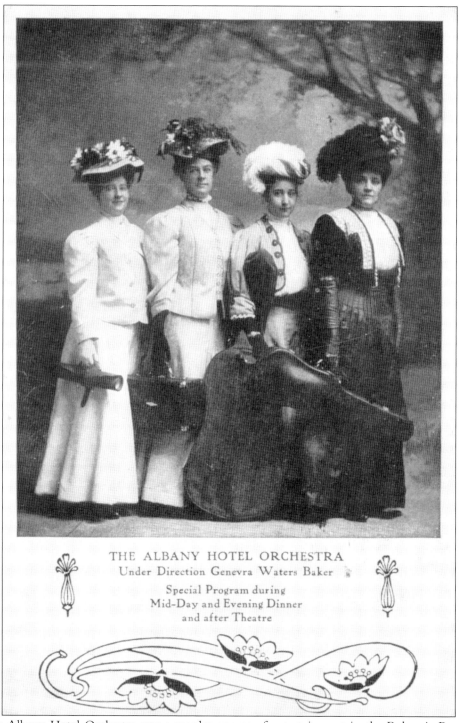

THE ALBANY HOTEL ORCHESTRA
Under Direction Genevra Waters Baker

Special Program during
Mid-Day and Evening Dinner
and after Theatre

The Albany Hotel Orchestra was a regular source of entertainment in the Bohemia Room. According to a Broadway Theater program advertisement of 1907, the Bohemia was the place to gather "where every attendant is alert to please you. Incidental to your enjoyment and meal, music rendered by Genevra Waters Baker's Bohemian Orchestra."

Pictured here is the fountain in the Colonial Room. Diners enjoyed an ambiance that included music, waiters in starched white uniforms, a large wine and liquor list, and excellent food. After dinner, women retreated to the salon for some gossip, and the men gathered in the Smoking Room for brandy and cigars.

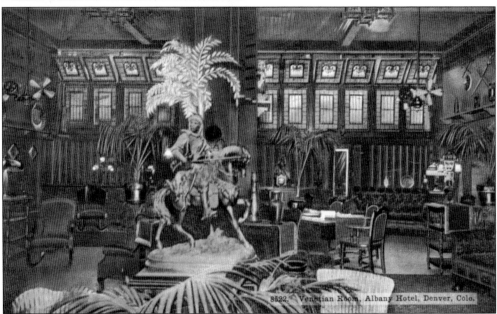

The Albany Hotel played host to many important figures of the 20th century, including silver king Horace Tabor and his wife, "Baby Doe," Senator Nathaniel Hill, Senator Edward O. Wolcott, and Senator Thomas Patterson, who became a later owner of the building. The Albany's Venetian Room is pictured here.

The Albany Annex was a large addition to the original building, which almost doubled the existing space. The family of Senator Thomas Patterson gained control of the hotel and ordered the demolition of the original building in 1938, replacing it with a sleek new 333-room structure. The hotel and annex were torn down in 1976.

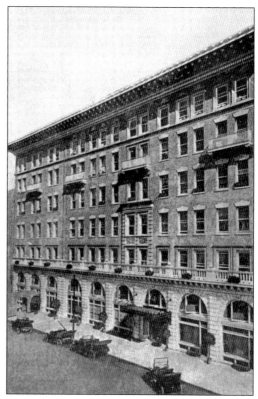

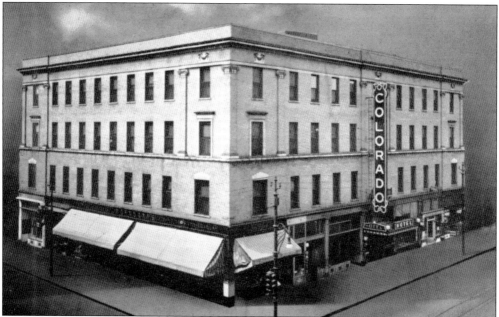

The four-story Colorado Hotel, at 408 Seventeenth Street at Tremont, sat diagonally from the Brown Palace Hotel. Lou Coffee's Steak House, very popular with the city's bankers and oilmen, was a ground-floor tenant for years. The building was acquired for demolition in 1973 by Denver oilman Marvin Davis. A high-rise office building occupies the site today.

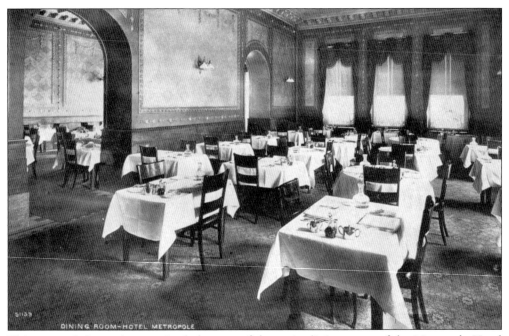

This postcard shows the restrained elegance of the main dining room of the Metropole Hotel around 1910. The back of this card states, "There is no better hotel table in the State than ours, either in quality or service. The beauty of our famous Dining Rooms make it doubly attractive."

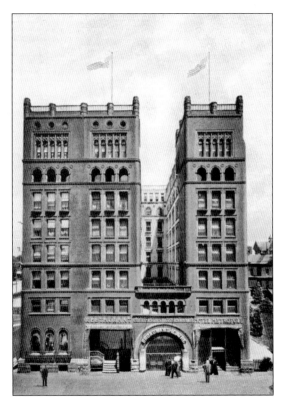

The Metropole Hotel, built in 1890 at 1756 Broadway, was fashionable with the carriage trade. Its main attraction was the Broadway Theater, attached to the back of the building. It was one of the grandest sights in Denver. Its auditorium was designed in an exotic East Indian style, and its stage was 40 feet deep and 75 feet high. The theater was removed in the 1950s, and the hotel was gone by the mid-1980s.

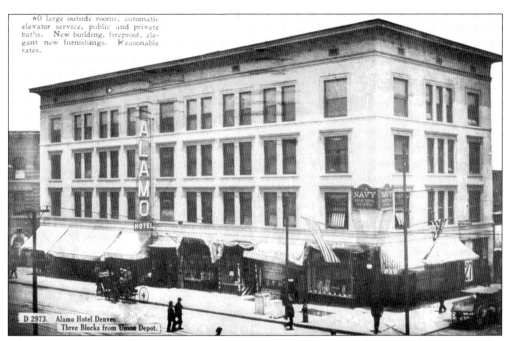

The Alamo Hotel was located at the northwest corner of Seventeenth and Market Streets. This card, from Leonard to "Miss Laura," reads, "Sorry for the delay in writing back to you. Do you look as sweet as those pictures show you do? They were fine!" The hotel has been replaced with a steel and glass high-rise office building aptly named Alamo Plaza.

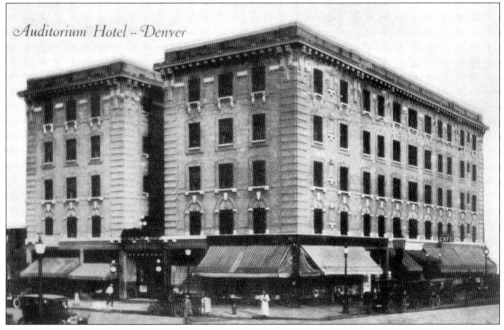

The Auditorium Hotel once stood at Fourteenth and Stout Streets, adjacent to the Denver Municipal Auditorium. The back of this card touts, "Every Bed the Best. Every Room Outside. Street cars one-half Block reach every place in Denver. A Nice Home-like Café in connection. Room rates: $1.50 to $3.50. Double $2.50 to $5.00."

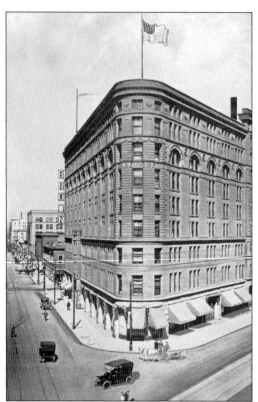

Henry Cordes Brown, a real estate investor who donated land for the Colorado State Capitol Building, hired architect Frank Edbrooke to build a grand hotel at the corner of Seventeenth Street and Broadway. The Brown Palace Hotel opened in 1892 and has remained grand in every way for 12 decades. The eight-story atrium has been the scene of everything from Stock Show exhibits to the annual Debutante Ball.

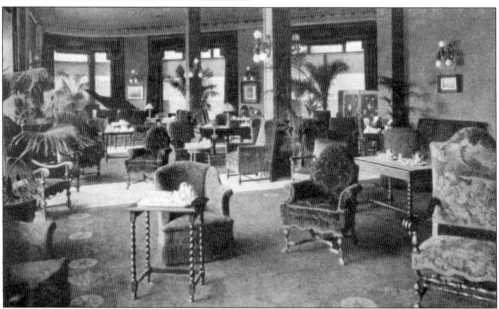

Throughout the years the hotel has hosted presidents Dwight Eisenhower, Theodore Roosevelt, William Howard Taft, and Bill Clinton, bandleader Paul Whiteman, Zsa Zsa Gabor, Jimmy Stewart, and Queen Marie of Romania. The Beatles stayed at the Brown when they played Red Rocks Amphitheater in 1964. Margaret "Molly" Brown stayed at the hotel shortly after her heroics during the sinking of the *Titanic* in 1912.

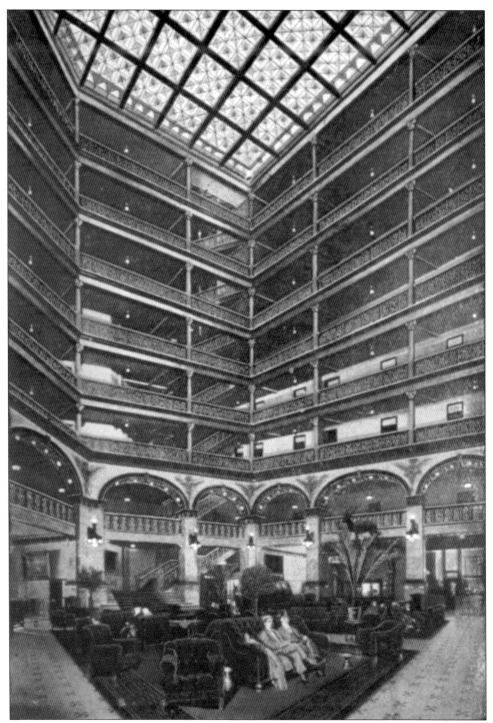

Afternoon tea has been a custom in the lobby of the Brown Palace Hotel for years. A stained glass skylight casts a pale light over the eight-story lobby, which has changed little since the hotel was built. Every year the National Western Stock Shows' Grand Champion Steer is displayed in this lobby.

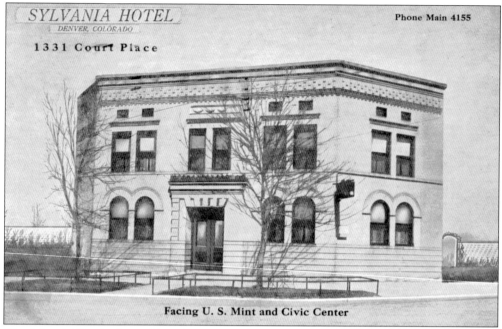

SYLVANIA HOTEL
DENVER, COLORADO

1331 Court Place

Phone Main 4155

Facing U. S. Mint and Civic Center

The Sylvania Hotel, pictured here in 1914, sat facing the Denver Mint and Civic Center where Court Place intersected with West Colfax Avenue. The message to the recipient of this card states, "Will you consider this desirable home for your precious bachelor personality? It is quiet, clean, convenient, and belongs to a mutual friend, who, for this unsolicited service, would be gratified, if he knew of it."

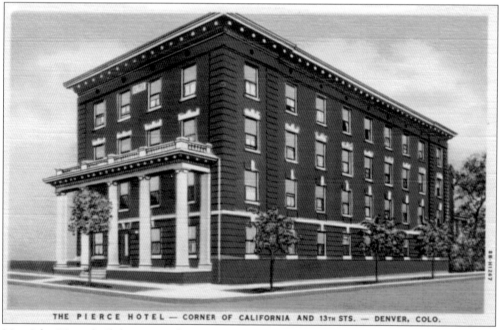

THE PIERCE HOTEL — CORNER OF CALIFORNIA AND 13TH STS. — DENVER, COLO.

Mrs. John Pierce built her namesake Pierce Hotel in 1909 at Thirteenth and California Streets. The four-story building was a classic example of the many hotel/apartments found throughout the downtown area during the first half of the 20th century. Almost all are now gone.

The Hotel Wellington, a three-story, 68 room building at 1450 Grant Street, faced west toward the State Capitol Building across the street. The capitol grounds were once surrounded with hotels, apartment houses, and Victorian homes. The Wellington was torn down, and the site has been a parking lot of years.

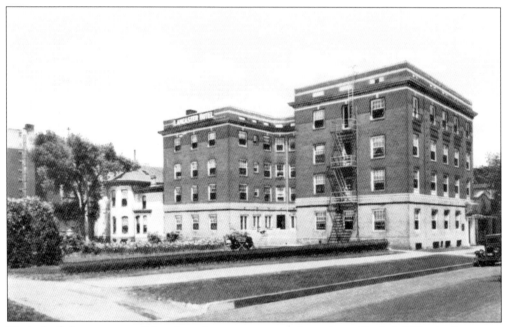

Typical of the many small hotels and apartments set throughout Capitol Hill, the Lancaster Hotel, built at 1765 Sherman Street in 1912, sat directly west and across the street from the El Jebel Shrine Temple and next door to the temple's garage. The Lancaster, seen here from Sherman Street, became a medical clinic in 1948 and has been replaced with a glass and steel high-rise building.

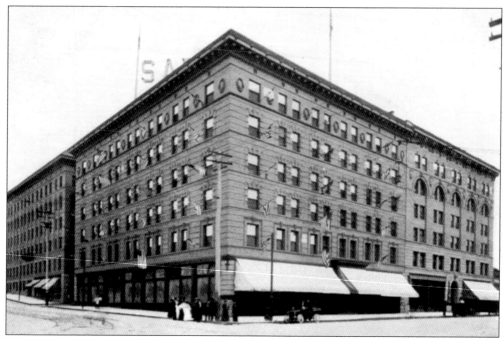

In 1902, David Dodge and Walter S. Cheesman, both prominent Colorado pioneers, saw a need for a reasonably priced luxury hotel as Denver was a rapidly growing city and was attracting tourists by the trainload. Work was started on Dodge's Shirley Hotel at the southwest corner of Seventeenth Avenue and Lincoln Street. The hotel opened in 1903.

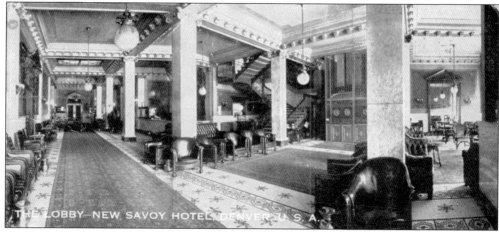

Soon to follow was Cheesman's Savoy Hotel next door, at Seventeenth Avenue and Broadway. An annex was built just south on Broadway, which became offices for the Denver Union Water Company. Both Dodge and Cheesman were directors of this company. Pictured in this c. 1910 postcard is the hotel's lobby.

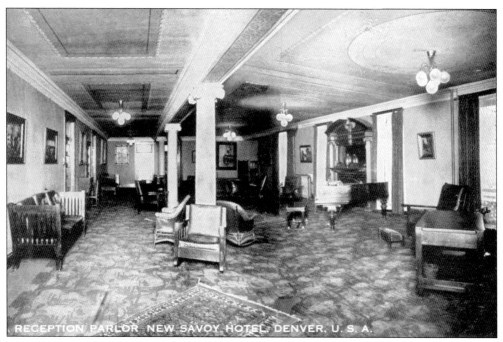

In 1921, Dodge bought out Cheesman's half, and the complex became known as the Shirley-Savoy Hotel. By this time, the hotel boasted more than 400 rooms. The annex eventually became part of the Shirley Savoy hotel complex, adding more space. The reception room, pictured here with its grand piano and electric lighting, was considered deluxe for the era.

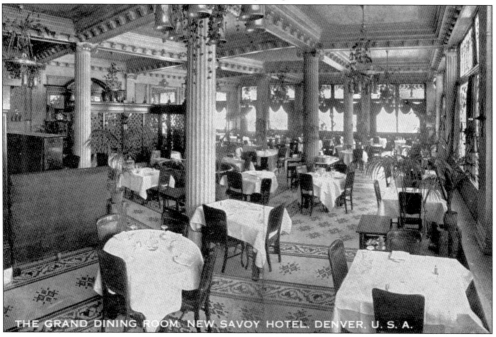

The elegant main-floor dining room attracted high society, cattlemen, and out-of-state legislators. For years, the hotel was a center of activity during the annual National Western Stock Show. The Shirley was torn down in the 1960s, and the Savoy followed a few years later.

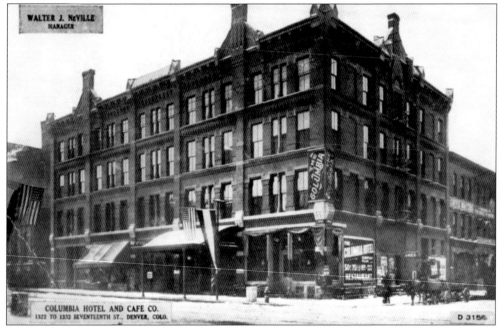

The Columbia Hotel, located at 1322–1332 Seventeenth Street across from the present Market Street Station, is a rare survivor, having been renovated and put to modern use. The chimneys have been removed, but the integrity of the structure remains intact. According to the painted exterior wall sign, room rates were 50¢, 75¢, and $1 per day. The postcard is from around 1908.

The Harvard Hotel was located at the northeast corner of Colfax Avenue and Pennsylvania Street. Colfax was once an elite avenue, with mansions lining both sides from Broadway to York Street. As commerce pushed its way up Colfax, these mansions were converted for use as hotels, apartments, and offices. Almost all of them were eventually demolished. A fast food restaurant sits on this corner today.

Razed in the late 1960s, the domed Adams Hotel was once an elegant inn. Built around 1902 at Eighteenth and Welton Streets and designed by architects Viggo and H.W. Baerreson, its main feature was the Dutch Room, a dining room with a giant stained-glass window depicting a windmill in the Holland countryside. The room was also decorated with vases of tulips and hand-wrought light fixtures with copper Dutch characters.

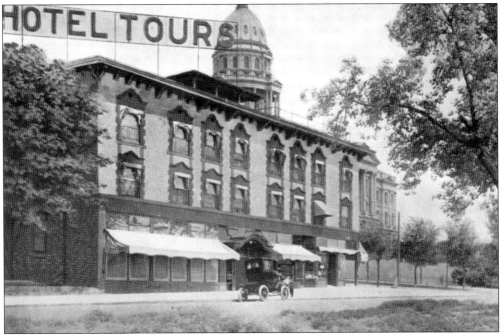

The Hotel Tours, at the northeast corner of Lincoln Street and Colfax Avenue, was popular for the first half of the 20th century because of its close proximity to the state capitol and the downtown business district. By the 1960s, however, it had seen its share of robberies, burglaries, and a well-publicized murder or two. The hotel is gone, and its former site has been a parking lot for several decades.

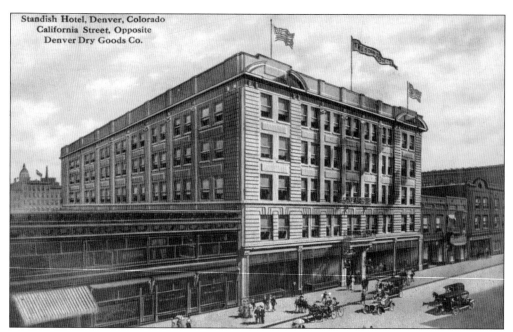

The four-story, 120-room Standish Hotel, located at 1530 California Street, was a major downtown hotel in the first part of the 20th century. It was purchased in 1958 by the Bank of Denver, then a first-floor tenant. Owned by a group of Texans for a number of years, the venerable hotel has been demolished, and the site is now a construction site.

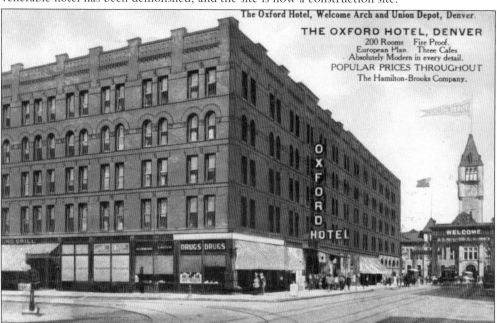

The Oxford Hotel, designed by Frank Edbrooke and constructed in 1890–1891, sits adjacent to Union Station at 1600 Seventeenth Street at Wazee. An annex was added in 1912. Due to its proximity to incoming trains and the central business district, the hotel was long a popular destination for weary travelers. The hotel survived the economic changes in lower downtown and thrives today.

Five

ENTERTAINMENT

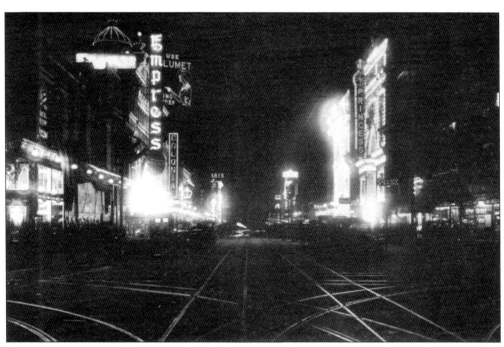

Curtis Street, pictured here, was the absolute center for entertainment during Denver's early days. Its theaters featured not only motion pictures and concerts but stage shows and elaborate musicals. Many theater employees served as singers, dancers, prop men, makeup artists, and costumers. Found along Curtis Street, at one time or another, were the America, Tabor, Novelty, Victory, Empress, Empire, and Isis Theaters.

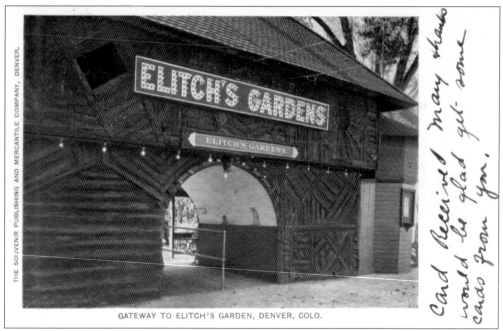

GATEWAY TO ELITCH'S GARDEN, DENVER, COLO.

Card Received many thanks would be glad get some cards from you.

Elitch Gardens, Denver's famous amusement park, sprang from a quaint apple orchard on the edge of town, purchased by husband-and-wife restaurateurs John and Mary Elitch, as a source of produce for their restaurant in downtown Denver. Pictured is the first gateway built at West Thirty-eighth Avenue and Tennyson Street.

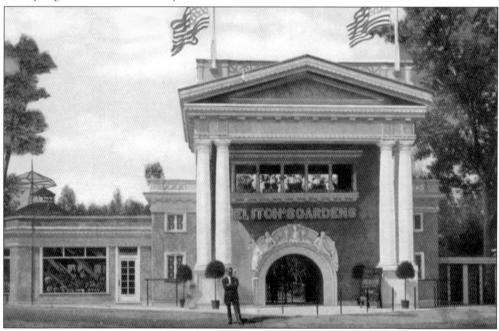

John Elitch had been involved in the theater as a side occupation, and Mary had an interest in flowers and animals. In 1890, they redeveloped part of the property as a garden and opened a small zoo that soon included lion cubs, peacocks, ostriches, bears, and monkeys. The original gateway was eventually replaced by this more elaborate edifice.

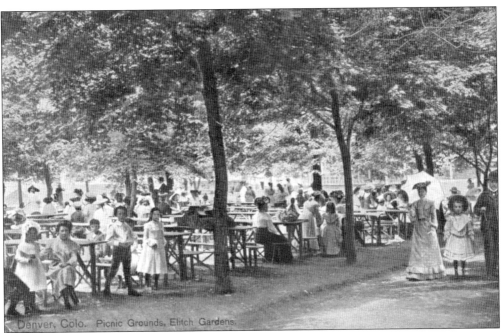

As the park's popularity grew, band concerts and vaudeville shows were added to the venue. John Elitch died suddenly in 1891, leaving Mary to operate the business alone. In 1901, she married Thomas Long, who had been working in the box office. The couple continued to add more attractions, including rides such as a roller coaster and carousel, a miniature train, and a penny arcade. A picnic area, seen here, gave pleasant respite from all the activity.

The Longs soon added a theater—one that was to become a national treasure. Over the years, those who graced its stage included Sarah Bernhardt, Edward G. Robinson, Frederic March, Grace Kelly, and Lana Turner. Helen Bonfils, daughter of *Denver Post* owner Frederick G. Bonfils, played an important part in the ongoing success of the theater and eventually married its director, George Somnes.

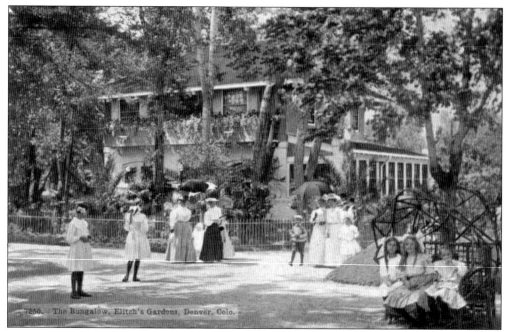

With the death of her second husband in 1906, Mary was faced with financial troubles. Businessman John K. Mullen took control of the operations and, with the help of others, made the financial decisions necessary to keep the park solvent. As Mary Elitch advanced in age, the business was sold to John Mulvihill, with the stipulation that Mary was to live on the property in her bungalow, pictured here, for the rest of her life.

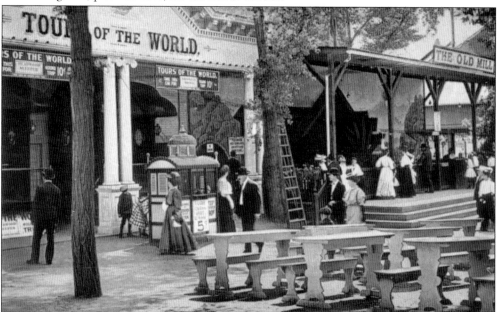

The park offered a wide array of diversions, which were quaint by today's standards. Pictured here are the "Tour of the World" and "The Old Mill." Others included ski ball, a toboggan, ping pong, a miniature railroad, shooting galleries, and even an Indian palm reader. The park offered "Under-the-Apple-Tree" luncheons, summer night dances, and children's days.

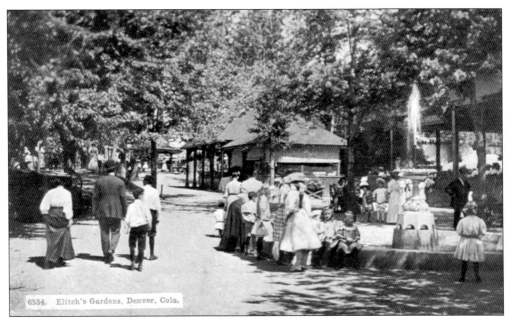

6534. Elitch's Gardens, Denver, Colo.

Under John Mulvihill's leadership, the park expanded with the addition of bigger and better rides, more entertainment, and astute financial control. This postcard shows an almost old-world setting found at the park during its early days. Sports were a draw, and a 1915 *Denver Post* advertisement publicized the "Berkeley Merchants v. the Swift Packing Company" game.

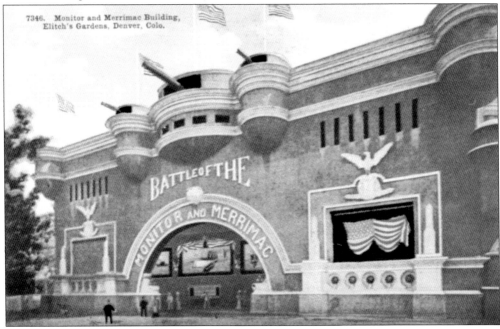

7346. Monitor and Merrimac Building, Elitch's Gardens, Denver, Colo.

One of the most ambitious amusements was the "Battle of the Monitor and Merrimac," which was acted out by Elitch's employees to awestruck audiences. Mary Elitch Long died in 1936. Arnold Gurtler, who had been working at the Denver Dry Goods Company downtown, spent a great deal of his off-time at Elitch Gardens. He came into the fold as Mulvihill's protégé and eventually his son-in-law.

Together, they increased patronage and made music a valuable commodity through well-publicized concerts and stage shows. The Trocadero Ballroom was built in the early 1900s to showcase local and national music talent, and crowds gathered weekly to dance to their favorite bands. National radio shows were also broadcast from the Trocadero.

The Trocadero played host to a variety of nationally known bands and orchestras, featuring bandleaders and musicians including Wayne King, Jimmy and Tommy Dorsey, Gene Krupa, Harry James, and Ray Noble. By the 1970s, however, ballroom dancing had become somewhat passé, and management decided to tear down the structure and replace it with a space for arcade games.

Elitch's had a penny arcade that was immensely popular. It featured coin-operated fortunetellers, orchestrions and player pianos, flicker-card movies, crane games, pinball machines, mechanical horseracing and gun games, tabletop bowling, and more. Those frequenting the arcade were treated to the ever-present smell of roasting peanuts and fresh popcorn.

John Mulvihill died in 1930, and the park was transferred to his son-in-law Arnold Gurtler. Management eventually passed to his sons, Jack and Arnold Jr. The park remained in the Gurtler family until it was moved to its present Platte Valley location in the mid-1990s. The old Elitch's site has been cleared for apartments and townhomes. The Elitch Theater still stands, and there have been efforts to restore it and reopen it.

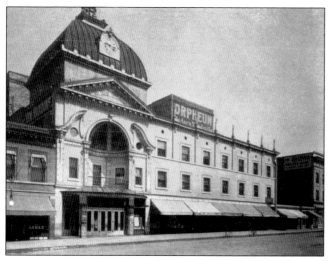

Most of Denver's early theaters offered not only motion pictures but live stage musicals, vaudeville, and burlesque. Organ concerts on one of the giant Wurlitzer organs were a big hit, as well as cartoons and contests for the kids, where prizes ranged from free movie tickets to new bicycles. A rooftop sign above the Orpheum Theater, seen here at 1537 Welton Street, advertises "Modern Vaudeville."

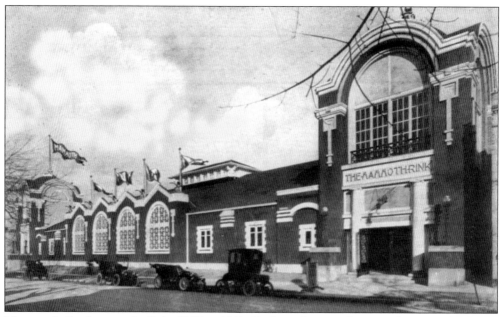

Mammoth Gardens was built in 1907 at 1510 Clarkson Street to house a skating rink but has had a long and checkered history. For a time, the building was used to house the Fritchle electric automobile manufacturing plant. Mammoth Gardens has also seen duty as a warehouse, an indoor public market, a sports center, and, now, the Fillmore Auditorium, a popular rock-concert venue.

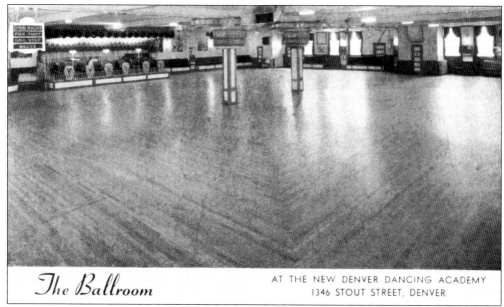

The Ballroom AT THE NEW DENVER DANCING ACADEMY
1346 STOUT STREET, DENVER

Denver was filled with dance halls and dancing schools when the Charleston was the rage. Patrons learned the newest dance moves to music from either a Victrola or a small dance band. Polished floors and large windows were the norm, as evidenced by the postcard above, from the Denver Dance Academy at 1346 Stout Street. The hanging sign reads, "Good Night, Fox Trot, One-Step, Waltz."

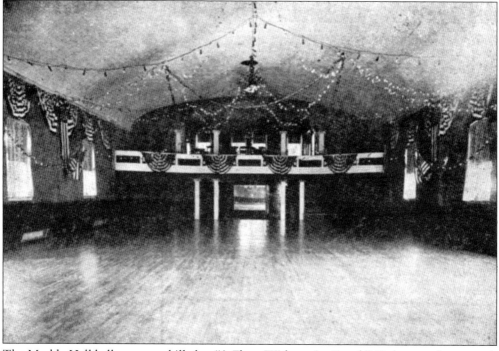

The Marble Hall ballroom was billed as "A Floor Without An Equal." Only one of many such dance hall/academies in Denver, it was located at 1514 Cleveland Place. The front of this postcard also touts, "A high class private ball room designed especially for clubs and family parties."

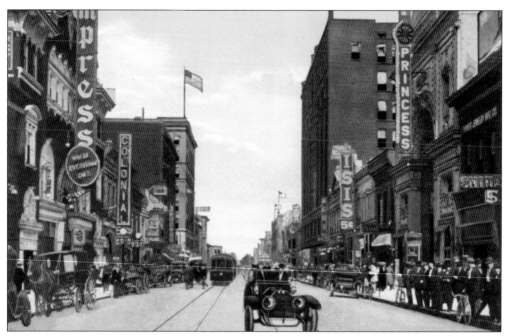

From Fifteenth Street all the way north to Twentieth Street, Curtis Street featured the most entertainment options to be found anywhere in Denver. Pictured here in about 1915 are the Princess, Isis, Colonial, and Empress Theaters. All were in the 1600 block of Curtis Street. Entertainment houses stretched all along the street corridor.

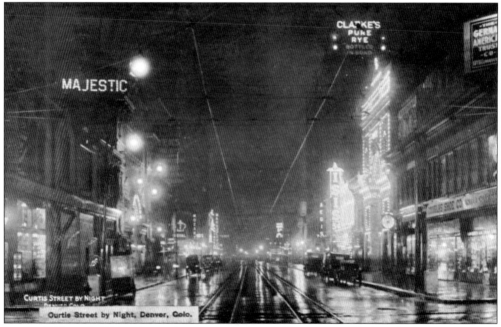

In the 1910s and 1920s, Curtis Street was Denver's "hot spot," filled with chop suey joints, peanut and popcorn vendors, saloons, hotels, and apartments. Honky Tonk piano music filled the air on most nights. Along with the usual fare, theaters featured concerts with singers, a small band, or one of the many theater organs, usually a giant Wurlitzer.

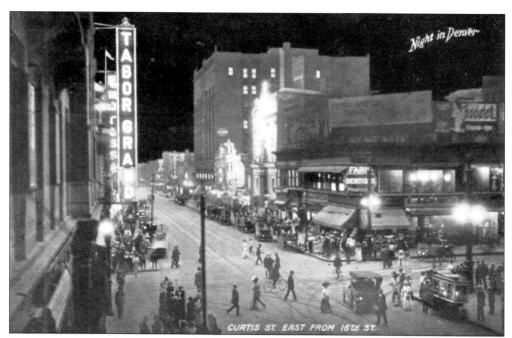

Denver was a city of theaters. This postcard, dated 1912, shows the Princess and Isis Theaters on the right, and on the left the Tabor Grand Opera House and the Empress Theater (sign partially obscured). There appear to be two curbside popcorn wagons in this scene.

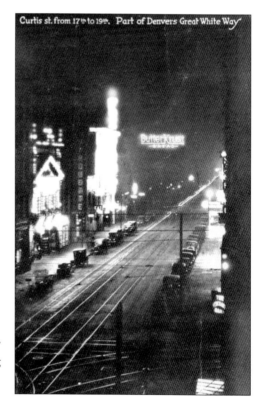

Another image of Curtis Street at night shows the Isis and Princess Theaters on the left and the Marquette Hotel and the Merchant Bank on the lower right. Curtis Street gained the reputation as "the brightest street in America," due to the thousands of electric bulbs covering the exteriors of these entertainment palaces. Note the many streetcar tracks.

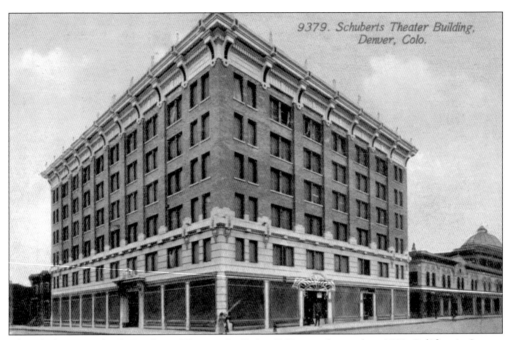

9379. Schuberts Theater Building,
Denver, Colo.

The Shubert Brother's Denham Theater, built in 1913, was located at 1810 California Street. The back of this card notes, "Denver's latest theater, which is to be one of the handsomest in the West. The new method of illuminating this building is especially attractive and well-fitted for the City of Lights." Note the dome of the Adams Hotel on the right.

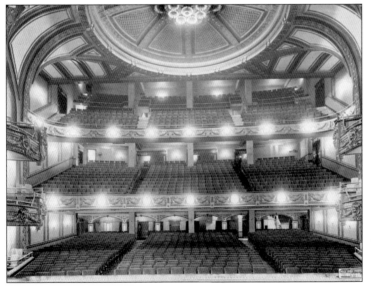

The six-story Denham Theater was entirely fireproof, and seated over 1,600 patrons. Stage shows, musicals, and vaudeville preceded the 1930 conversion to motion pictures. The Shuberts introduced the likes of Ed Wynn, Ray Bolger, Fanny Brice, and Al Jolson. The Denham Theater closed in 1974 and the building has been demolished.

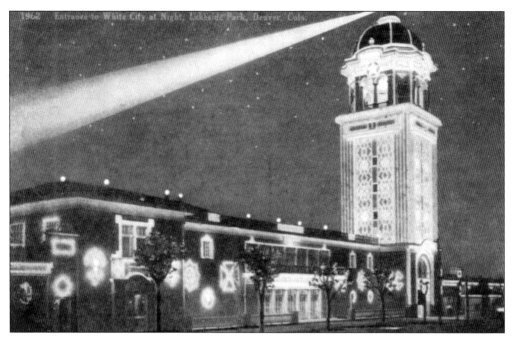

Thousands of Denver children spent a portion of their summers riding the rides at Lakeside Amusement Park since it opened its gates in 1908 at 4601 Sheridan Boulevard. First known as White City, it quickly gained a reputation to rival any amusement park in the country. It was, and still is, a fascinating and exciting way to pass a summer's day.

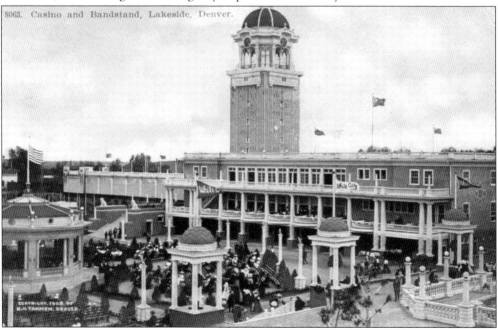

8063. Casino and Bandstand, Lakeside, Denver.

The park was officially opened by the daughter of Adolph Zang, who was the president of the Lakeside Realty and Amusement Company and an owner of the Zang Brewing Company. The early years offered rides such as an elaborate merry-go-round, the Chute, and a roller coaster. The park featured a casino and a large indoor swimming pool.

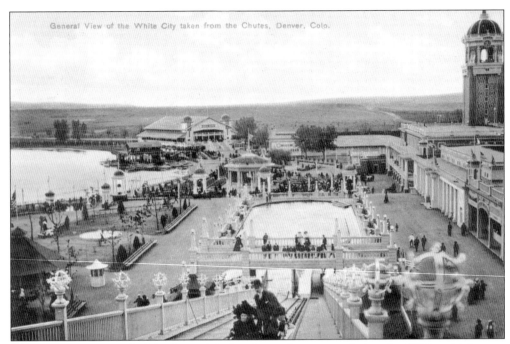

Benjamin Krasner worked for the park before becoming owner during the 1930s, which some consider the park's golden years. It was he who named Lake Rhoda after his daughter. Twin steam engines circled the lake. The park also featured picnic areas and concession stands.

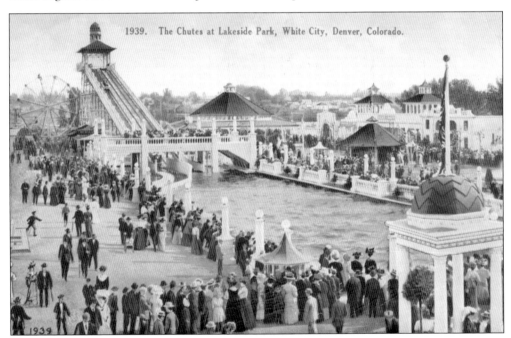

1939. The Chutes at Lakeside Park, White City, Denver, Colorado.

The Chutes, pictured here, was a centerpiece of the park during the early years. Later attractions included the Fun House, bumper cars, speedboats on the lake, stockcar races, and demolition derbies. Benjamin Krasner died in 1965 and his daughter Rhoda continues to operate the park today.

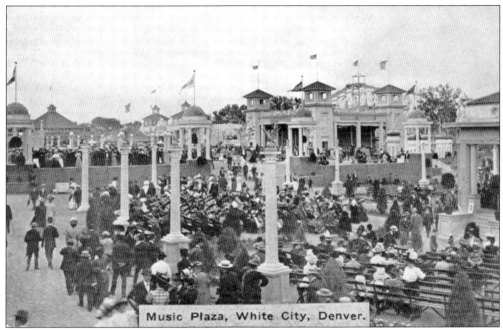

Music Plaza, White City, Denver.

This postcard shows the "Music Plaza," where band concerts and musicales were held every summer. Music played an important part in the ongoing success of the park, and it was here that many of Denver's children were first introduced to live music.

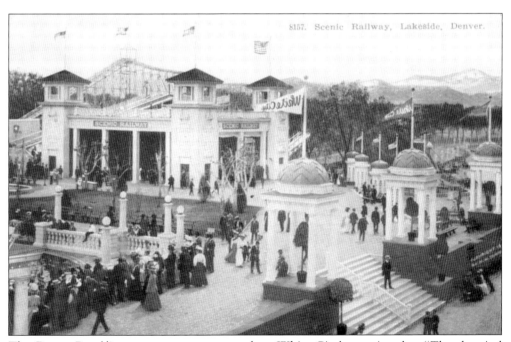

8157. Scenic Railway, Lakeside, Denver.

The *Denver Republican* newspaper commented on White City's opening day, "The electrical display from the smallest cluster of lights on the far side of the peaceful lake to the flashing searchlights on the pinnacle of the dazzling tower outstrips anything ever before seen in this part of the country."

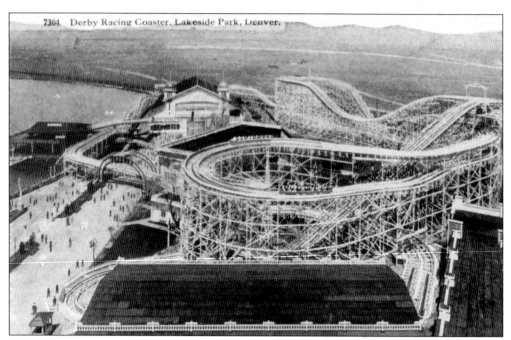

The roller coaster at Lakeside has always been a main attraction. The front of this postcard identifies the scene as "Derby Racing Coaster, Lakeside Park, Denver." Speed has replaced the tameness of a century ago, although small children can enjoy the 15 rides in Kiddies' Playland.

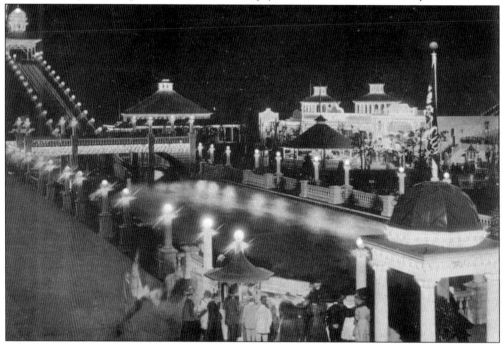

This postcard shows the Chutes at night when the park was a dazzling display of electric lights. Today, the park features a drop tower and roller coaster, among many other rides, and hosts family picnics and other group events. The park has operated from the same spot for over 100 years.

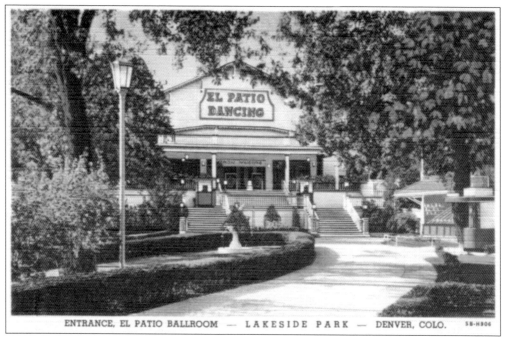

ENTRANCE, EL PATIO BALLROOM — LAKESIDE PARK — DENVER, COLO. 58-H906

The El Patio Ballroom was immensely popular during the big band era. The back of this card states, "A stairway to the stars leads up to Lakeside El Patio Ballroom of exotic Spanish design, which overlooks beautiful Lake Rhoda. Its specially constructed maple floor provides a satin-smooth surface for 3,000 dancers nightly."

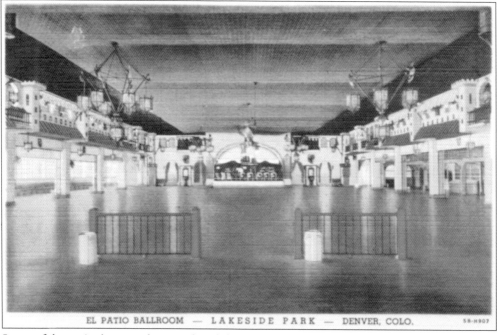

EL PATIO BALLROOM — LAKESIDE PARK — DENVER, COLO. 58-H907

Some of the nation's top orchestras played the El Patio Ballroom, and dancing as entertainment grew during the 1920s and 1930s. Dance marathons were a huge hit, where couples would bolster each other up for hours, and sometimes days, for a chance to win a cash prize.

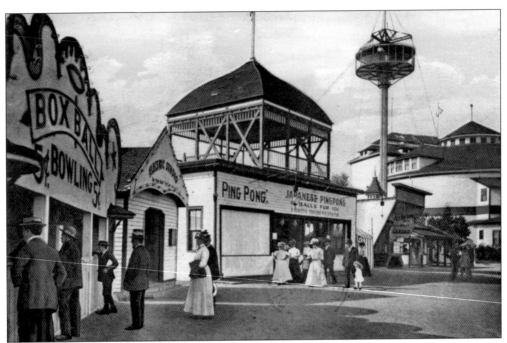

Manhattan Beach, once located at the northwest shore of Sloan's Lake, is almost completely forgotten by most Denverites today. The sprawling park featured a large summer stock theater, (pictured here on the right), rides, animal exhibits, and a roller coaster. Popular boat rides were given on the *City of Denver*, which ultimately sank in a storm.

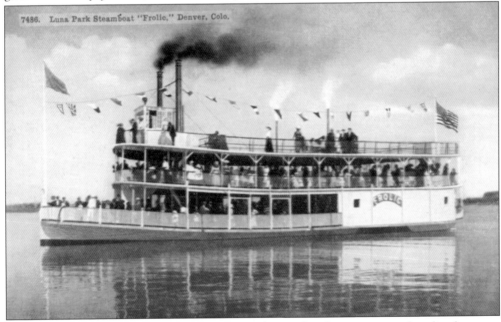

The theater was destroyed by fire in 1906. Manhattan Beach was reopened under the name Luna Park in 1909. It was around that time that it began losing business to its main competitors, Elitch Gardens and White City (Lakeside). Once again named Manhattan Beach, the park was closed around the start of World War I. Here, the *Frolic* is seen navigating Sloan's Lake.

Six

RESTAURANTS AND CAFÉS

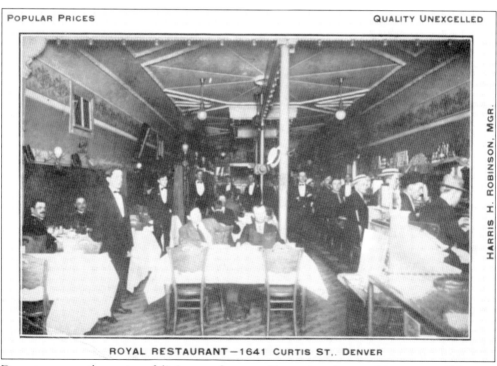

POPULAR PRICES QUALITY UNEXCELLED

HARRIS H. ROBINSON, MGR.

ROYAL RESTAURANT—1641 CURTIS ST,. DENVER

Downtown was the center of dining out for many Denverites. Some of the more well-known establishments are still talked about today in certain circles, such as the Manhattan Restaurant at 1633–1635 Larimer Street, Pell's Fish and Oyster House at 1514–1518 Welton Street, and Baur's at 1512–1516 Curtis Street, which was famous for its catering, confections, and desserts. The Royal Restaurant, pictured here in about 1910, was located at 1641 Curtis Street.

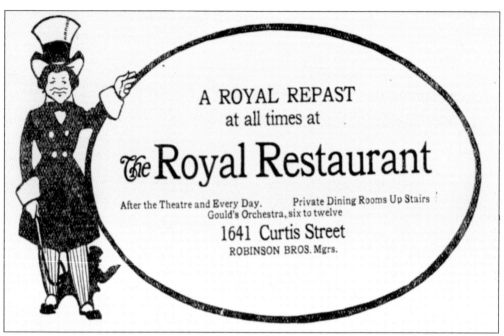

Aside from bucolic scenes of mountains, parks, city streets, and sweet sayings found on most postcards of the era, advertisers discovered that postcards were an effective marketing tool to boost the tourist trade. Here, the Royal Restaurant touts, "After the Theatre and Every Day. Private Dining Rooms Up Stairs. Gould's Orchestra, six to twelve."

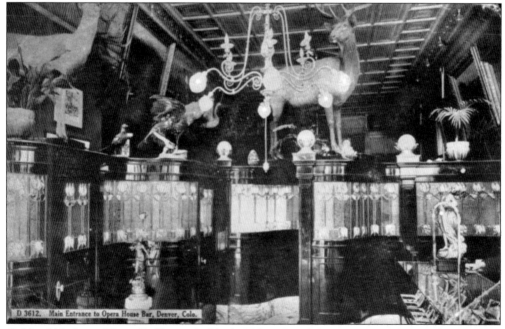

Goldsmith's Opera House Buffet was inside the Tabor Grand Opera House at Sixteenth and Curtis Streets. This plush theater was built in 1880–1881 by Leadville silver king Horace Tabor and was one of Denver's most popular entertainment houses for the next two decades or so. The building was demolished in 1964 for the Denver branch of the Federal Reserve Bank of Kansas City.

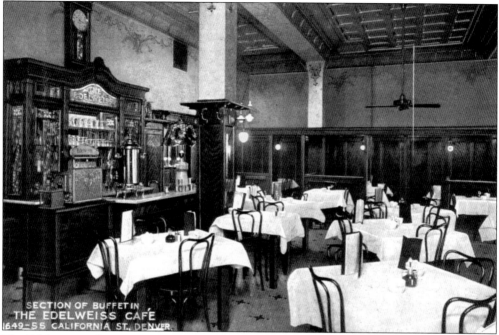

The Edelweiss Cafe, at 1644 Glenarm Place, stayed open late and attracted newspaper reporters, businessmen, and the occasional night owl. During its heyday, a ham sandwich was 30¢ and coffee was 5¢. In 1960, Midland Savings and Loan Association purchased the Edelweiss building, which adjoined the 10-story Midland offices just to the west. Luxury high-rise residences occupy the site today.

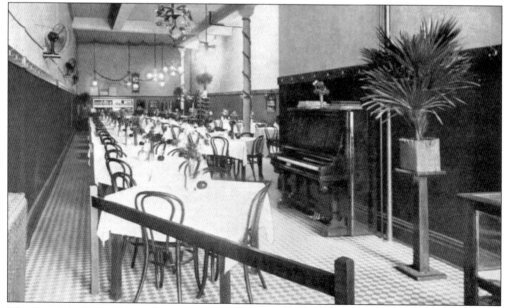

The People's Cafeteria was located at 1617 Welton Street. The front of this c. 1910 postcard instructs, "Up 16th to Welton, then 35 steps east and get a home-cooked meal. Rogers and Richardson, Prop's." Note the electric fans in this pre–air conditioner era, and the piano used to entertain the lunch crowds.

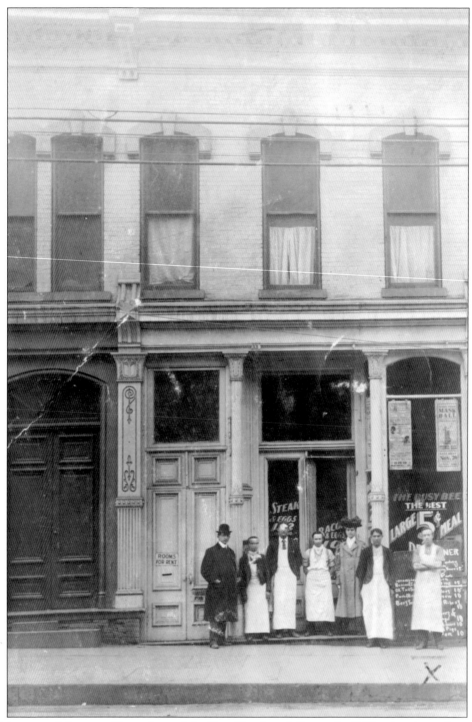

This postcard shows staff members of the Busy Bee Lunch Room in 1907, when it was located at 1312 Fifteenth Street "just below Larimer." A sign on the window advertises, "The best large five-cent meal." An advertisement in a 1907 Crystal Theater program boasts, "Quick Service, Open All Night, Good Coffee. All Full Dinner Orders 10¢."

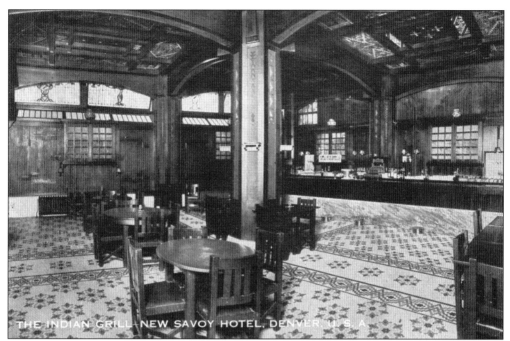

The Indian Grill, pictured here in about 1905, was part of the old Shirley-Savoy Hotel complex, which included the two side-by-side hotels and an annex building. Note that the room has inlaid ceramic-tile flooring, an Indian motif inset into the arched ceiling, and stained-glass windows.

Otto Baur was a baker, confectioner, and caterer in the early years of Denver. He opened his O.P. Baur Confectionery Company at 1512 Curtis Street in 1891, and it quickly became one of downtown's busiest spots. Baur's sold fresh-baked cakes, pies, cookies, and other assorted pastries. Baur's ice cream was immensely popular and was found at almost every Denver birthday party.

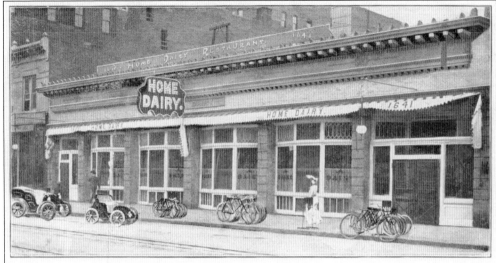

GREETINGS FROM THE HOME DAIRY THE NOTED PLACE OF DENVER, UNDER THE ORIGINAL MANAGEMENT. THE LARGEST RESTAURANT ON ONE FLOOR IN THE UNITED STATES. THE PLACE WHERE YOU GET GOOD THINGS TO EAT AT POPULAR PRICES. HOTEL ALBERT UNDER SAME MANAGEMENT.

The salutations on this postcard read, "Greetings From the Home Dairy, the Noted Place of Denver, Under the Original Management. The Largest Restaurant On One Floor In the United States. The Place Where You Get Good Things To Eat At Popular Prices. Hotel Albert Under Same Management." It was located at 1629–1641 Welton Street.

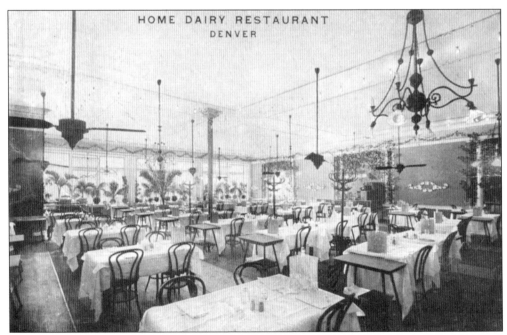

HOME DAIRY RESTAURANT
DENVER

The Home Dairy Restaurant was established in 1890 and quickly became a popular downtown eatery, especially with the Stock Show crowd. The owner, August Mattei, was father-in-law to local businessman Joe Onofrio. Mattei sold out in 1945 to Panayes Dikeou, who planned to build a 1,600-seat theater, a venture that never came about. In 1948, the building was reduced to dust.

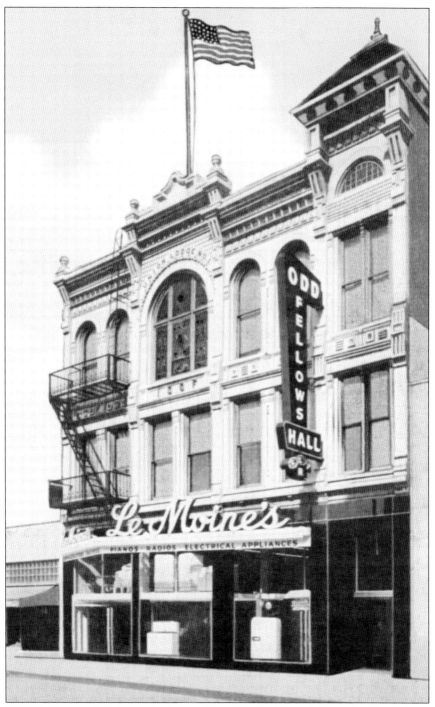

Dutch Mill Café occupied the main floor of the Odd Fellows Hall in a building designed by Emmett Anthony and built in 1889. The café opened in 1910, with waitresses that were almost exclusively blond and dressed in Dutch costumes complete with wooden shoes. Chorus girls sang popular songs of the day while an orchestra played on the balcony. The café closed in 1935, but the building is still standing at 1545 Champa Street.

THE HOFF-SCHROEDER CAFETERIA
1545-1547 WELTON STREET, DENVER, COLO.

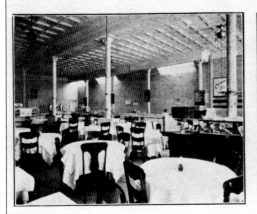 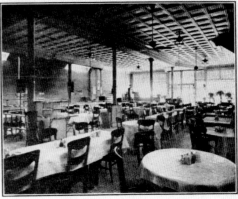

DENVER'S LARGEST, FINEST AND MOST POPULAR CAFETERIA

Matilda Hoff came to Denver from Canada with her young daughter in 1899 with only $5 in her pocket. She secured enough credit to buy a small lunch wagon and soon expanded into the cafeteria business with her son-in-law Charles Schroeder. Her venture at 1545 Welton Street was extremely successful and became one of downtown Denver's largest restaurants. Hoff died in 1936.

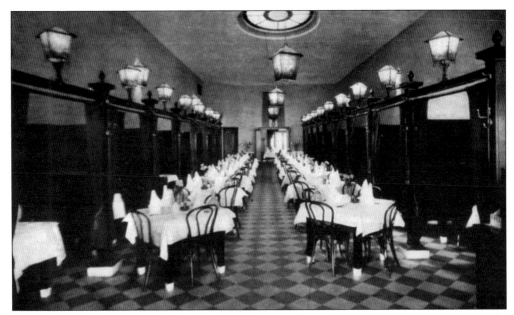

The Parisienne Rotisserie Inn was housed in a narrow space at 1721 California Street, not far from Denver's theater row on Curtis Street. At its height, the Parisienne was the only true French restaurant in the city and was the predecessor of the very popular Boggio's Parisienne Restaurant, which was located farther east, near Broadway and Tremont Place.

Mozart Orchestra

FRED A. BAKER
Director

6 p.m. to 1 a.m.

Mozart Orchestra

FRED A. BAKER
Director

6 p.m. to 1 a.m.

Cafe Mozart

1647=49=51 Curtis Street

Café Mozart, once located at 1647–1651 Curtis Street, was only one of many popular dining establishments downtown. According to the back of this postcard, the Mozart offered "Meat Pudding, Cold Artichoke, Cold Boiled Whitefish, Kalter Aufschnett, Jellied Consomme in Cup, Cold Stuffed Crab, Iced Clam Broth in Cup." It billed itself as the "only café in the West serving Genuine Budweiser Beer on Draught."

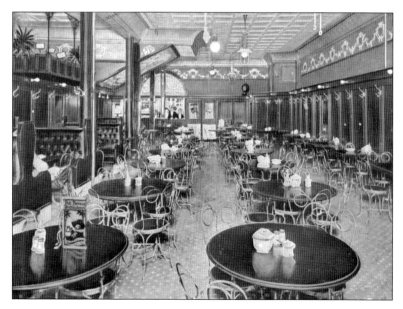

In the era of beer steins and 5¢ cigars, the Famous Café doubled as a restaurant and saloon. It was located at 1000 Fifteenth Street. Note the room has "ice cream parlor" chairs, an embossed tin ceiling, and a large beveled-glass window over the serving station.

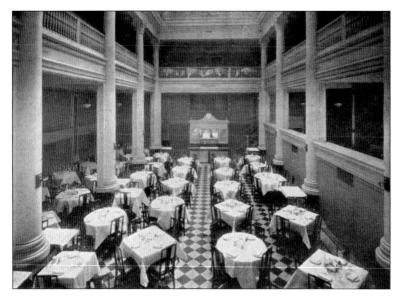

The back of this postcard states, "The main dining room, Café Alpine Rose, 1648 Glenarm Place. Telephone Main 7659. Denver's New and Beautiful Restaurant. Open from 6:00 a.m. to 1:00 a.m. Private Dining Rooms. Bakery and Lunch Counter. Moderate Prices."

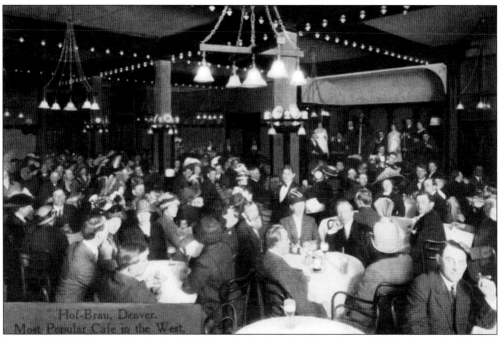

Located at 1524 Curtis Street, the Hof-Brau Café was one of many popular restaurants and cafes downtown from the 1900s to the 1930s. Among others were the Manhattan, the Watrous Café, the Blue Parrot, Holland's, the Yellow Lantern, the Budweiser Grill, the Bay Oyster House, and the Navarre Café.

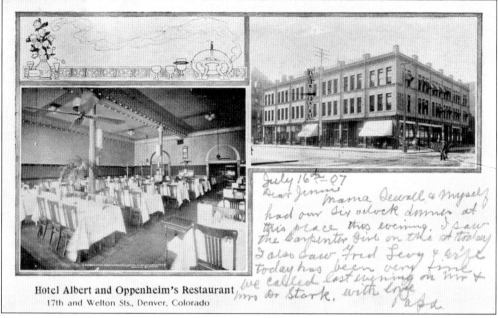

Hotel Albert and Oppenheim's Restaurant
17th and Welton Sts., Denver, Colorado

Oppenheim's Restaurant was in the Hotel Albert (later known as the Kaiserhoff and then the Kenmark) at 530 Seventeenth Street. The inscription on this card reads, "July 16, 07. Dear Jennie, Mama Sewall and myself had our six o'clock dinner at this place this evening. I saw the Carpenter girl on the st today. I also saw Fred Levy and wife. Today has been very fine. We called last evening on Mr. and Mrs. Dr. Stark. With love, Papa."

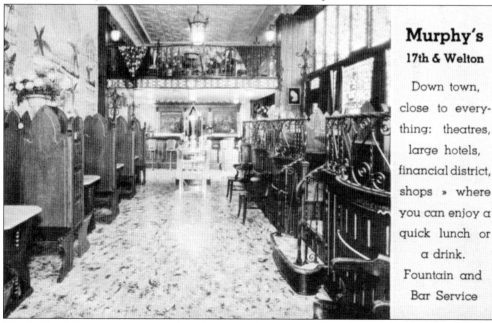

Murphy's

17th & Welton

Down town, close to everything: theatres, large hotels, financial district, shops » where you can enjoy a quick lunch or a drink. Fountain and Bar Service

The back of this c. 1925 postcard reads, "Murphy's Fine Food. In Denver—17th and Welton. Famous for our Chili and Chicken Tamales. Good food is good health. Our quality is always higher than the price." The interior shows a typical 1920s Spanish influence, with its wrought iron railings, iron-and-glass lighting, and a Spanish shawl draped over the balcony.

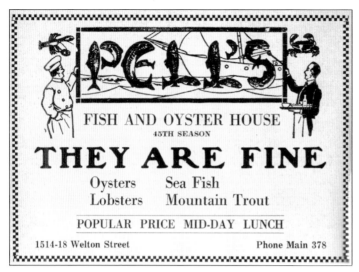

Pell's Oyster House was one of the city's most popular dining establishments and occasionally used the printer's art to mail out postcards. Founded in 1881 by George Pell, the restaurant was once housed in the basement of the Tabor Building. It then moved to 520 Sixteenth Street. It operated there for 25 years and then moved to 1514–1518 Welton Street. It closed its doors in 1937.

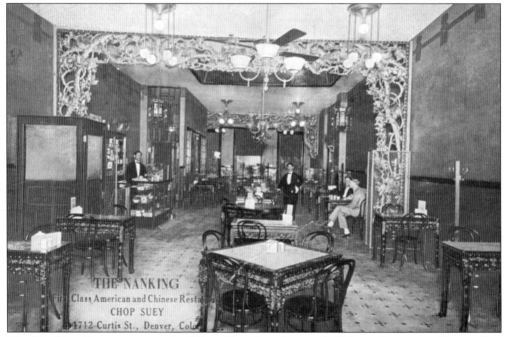

The Nanking Restaurant was the "First Class American and Chinese Restaurant," according to the front of this card. It is seen here in about 1913. Located at 1712 Curtis Street, in the heart of Denver's theater row, it was advertised in the city directory as "the finest chop suey house in the West."

Seven

AROUND TOWN

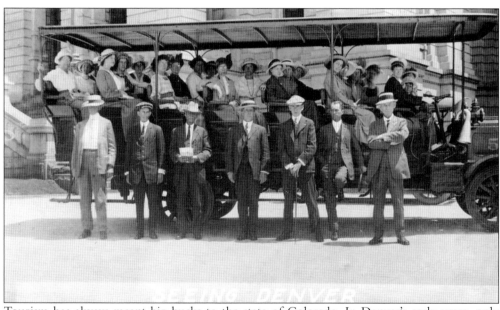

Tourism has always meant big bucks to the state of Colorado. In Denver's early years, only the heartiest souls would venture to Colorado to take in the wonders of the great Rocky Mountains. There were no superhighways and no gas stations every half-mile. The city of Denver, however, made certain that creature comforts were readily available to all who came to their fair city to partake of its charm.

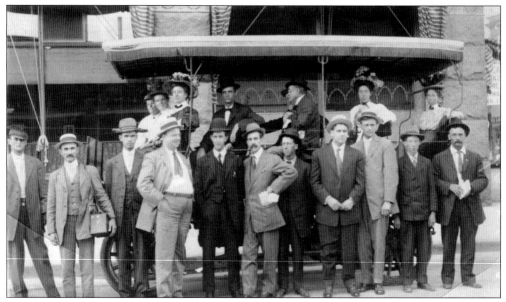

The first tourists came by wagon, and later by train, staying at one of the many hotels surrounding Denver's Union Station, including the American House, Oxford, Barclay, and Windsor Hotels. The Brown Palace played host to the upper crust coming into town to visit. The Chamber of Commerce did much to boost tourism during the first years of the 20th century, touting Denver as a city with every modern convenience.

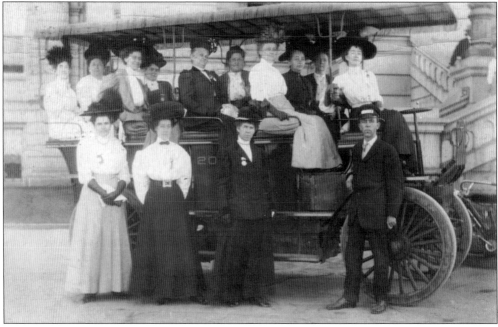

Tourism really took off in the 1910s and 1920s, due to the advent of the automobile and quicker and safer travel. During those years, however, tourists who came to see the splendors of the state were in for a real adventure because there were no highways and many of the roads into the hills of Colorado were still unpaved. The Denver Mint, Daniels and Fisher tower, and the Colorado State Capitol Building were some of the few stops on these tours.

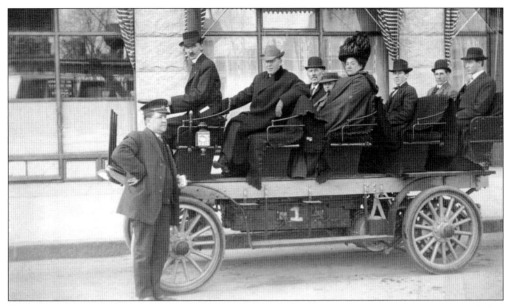

Economics deemed that large buses made more money than eight or ten-seater automobiles. The downtown shopping district along Sixteenth Street and City Park, Cheesman Park, and Washington Park all became popular sites along these routes. A few drivers offered trips to the outskirts of the city, places that were considered "in the sticks," such as Arvada or Englewood.

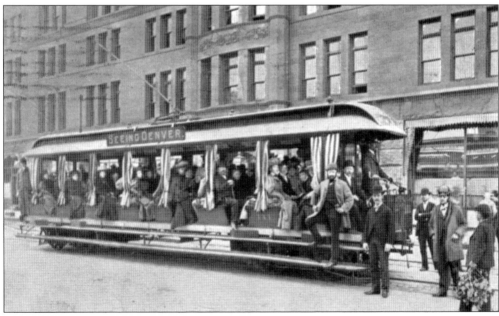

Some tour buses were built "trolley style," with open-air seating that held a large number of gawking tourists. Most of these sightseeing companies picked up their fares at the Brown Palace Hotel, pictured here, and had offices scattered throughout the downtown area. Tour buses continue to be a popular way to pass the time in Denver.

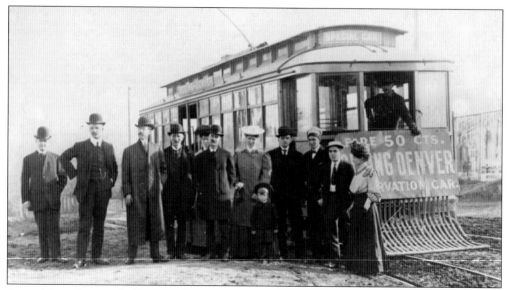

A special touring car, built on tracks, is seen in this c. 1915 postcard. The sign above the driver's compartment reads, "Special Car," while the one underneath reads, "Fare 50 cts. Seeing Denver. Observation Car." Postcards of this era cost one penny to mail.

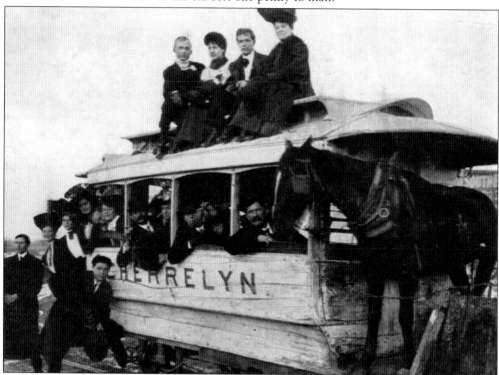

The Cherrelyn horse car line was constructed in 1883 and ran until 1910. The line started at what is now Hampden Avenue and Broadway in Englewood, which is at the southern edge of Denver. The car was pulled by a horse uphill for a full mile along a set of tracks to Broadway and Quincy Avenue, where the horse was unhitched and put on the back of the car. Gravity pulled the car back to its starting point. The restored car is now at the Englewood City Hall.

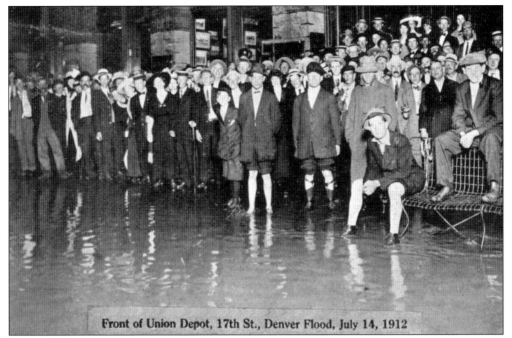

Front of Union Depot, 17th St., Denver Flood, July 14, 1912

Although major flooding in Denver is rare, it has happened. In July 1912, the banks of Cherry Creek overflowed due to heavy rainfall. It was uncommon for a disaster of this nature to be depicted on the front of a postcard, but the event was exciting enough to be worthy of the publicity.

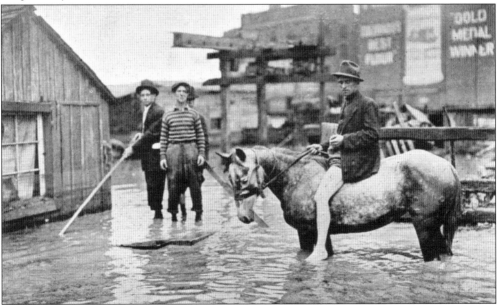

This postcard shows rescuers on horseback. The *Record Journal of Douglas County* reported, "The rain and hail was the worst that has visited this section for many years, and a great amount of damage was done to crops in many localities. The big rush of water that came down the creeks did a great amount of damages to roads and bridges. Over a dozen bridges in the county have been damaged."

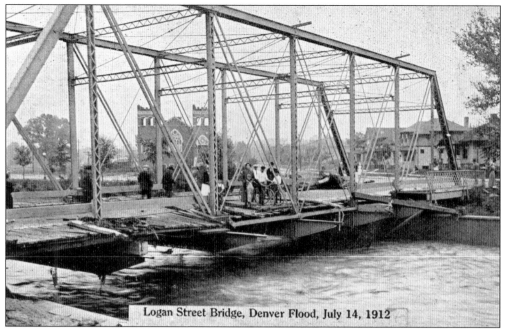

Logan Street Bridge, Denver Flood, July 14, 1912

A family with their bicycles surveys the damage at the Speer Boulevard and Logan Street bridge. Many bridges around the city were partially or completely destroyed. Downtown and south Denver received the brunt of the damage. In the background is the Mother of God Catholic Church, which is still standing.

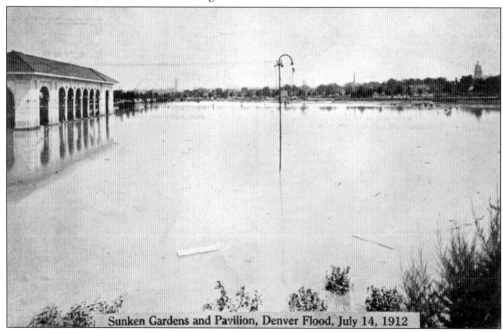

Sunken Gardens and Pavilion, Denver Flood, July 14, 1912

West High School's Sunken Gardens lived up to its name in this photograph. Aside from the flood of 1912, the banks of Cherry Creek overflowed in 1864 causing widespread damage downtown. The Castlewood Dam broke in 1933, flooding Cherry Creek again and causing extensive damage. In 1965, the South Platte River flooded a good portion of central Denver.

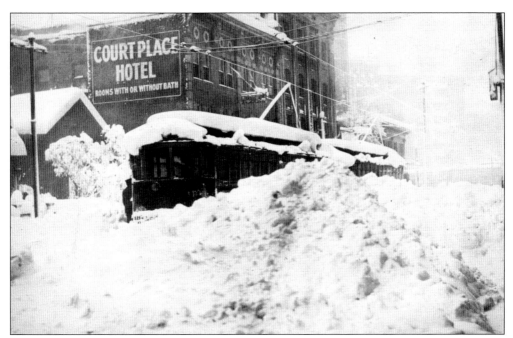

Denver has had its share of natural disasters. Major snowstorms in 1982 and 1983 brought the city to a standstill. This postcard depicts the storm of 1913, which dumped a record 45 inches from December 1–6. A trolley is stuck on its tracks in the 1600 block of Court Place. The building behind the trolley was later home to Duffy's, an immensely popular tavern for 50 years before closing in 2006.

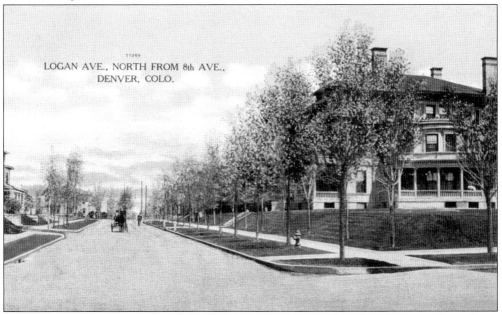

Capitol Hill, just east of downtown, was once one of Denver's wealthiest residential neighborhoods. It was home to the likes of industrialist Charles Boettcher, silver king Horace Tabor, and *Titanic* heroine Margaret "Molly" Brown and her husband, J.J. This c. 1910 postcard depicts the home of mining tycoon John F. Campion, which was located at 800 Logan Street.

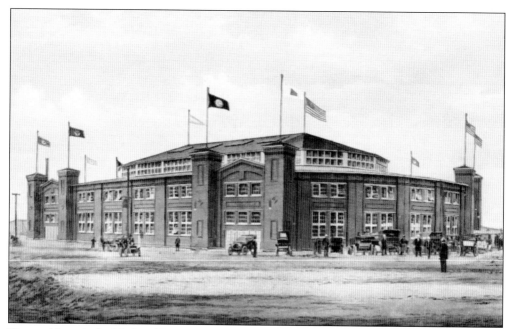

Pictured here is the National Western Stock Show pavilion. The reverse of this postcard states, "The Denver Union Stockyards cover 40 acres of ground and have a yarding capacity of 30,000 cattle, 30,000 sheep, 20,000 hogs and 2,000 horses and mules. This building has one of the largest show rings in the world and a seating capacity of 7,500."

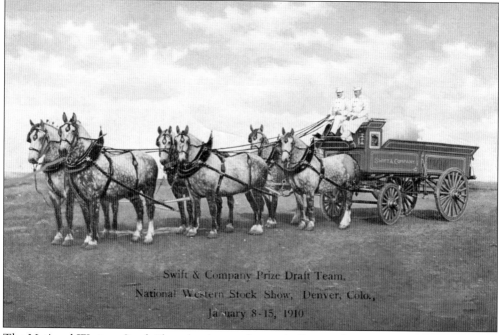

The National Western Stock Show has been a fixture in Denver for over 100 years. It has been located at Forty Sixth Avenue and Humboldt Street in north Denver. But as this book goes to press, there is talk of moving the event out of the area and possibly to a location northeast of Denver. The original pavilion was built around 1907–1908.

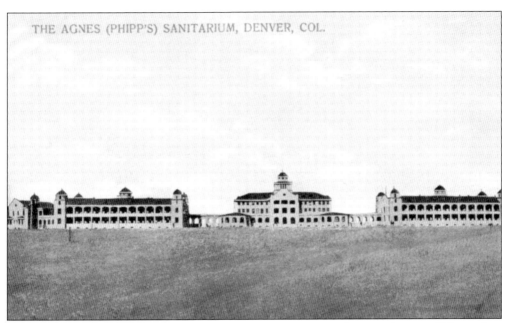

Phipps Sanitarium was erected in 1903 by Senator Lawrence Phipps in honor of his mother, Agnes. It was here that many people from all over the country were treated for the then-dreaded "consumption," now known as tuberculosis. The threat of tuberculosis eventually subsided, and the buildings later became part of the Lowry Air Force Base complex.

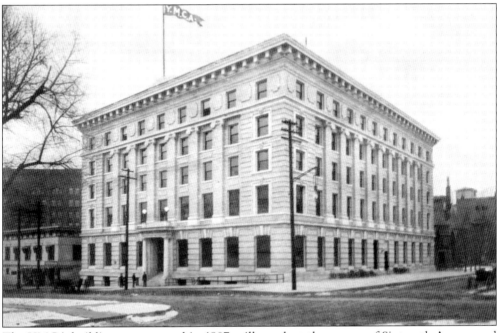

The YMCA building, constructed in 1907, still stands at the corner of Sixteenth Avenue and Lincoln Street. In the 1920s, a high school and junior college were located within its walls, and it provided housing for many of the servicemen on leave from overseas during World War II. An addition was built to the north in 1961.

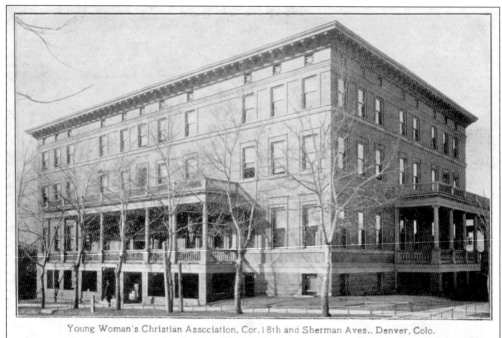

Young Woman's Christian Association, Cor. 18th and Sherman Aves., Denver, Colo.

This branch of the YWCA was located at the northwest corner of Eighteenth Avenue and Sherman Street, adjacent to the El Jebel Shrine Temple. Opened in 1900, it was a safe haven for young women coming to the city seeking employment and guidance. These women stayed in dormitories until they were able to secure employment and move out on their own.

The YWCA offered a number of valuable moral and social tools to those who desired them. Books were available, as well as training programs and physical exercise programs. The YWCA left the Sherman Street building in the late 1960s, and the Denver Free University briefly occupied the building before it was torn down a few years later.

The YWCA's downtown branch, pictured here at 1545 Tremont Place, opened in 1927 in the heart of Denver's business and financial section, giving young women shelter while allowing them to train for specific jobs in the area and at the same time offering guidance and support. The YWCA programs were immensely popular during the first half of the 20th century.

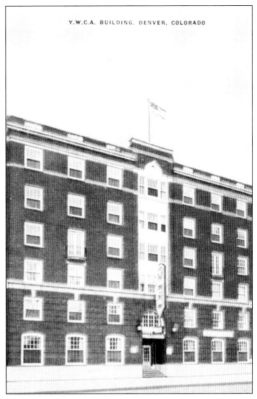

Y.W.C.A. BUILDING, DENVER, COLORADO

THE DOWNTOWN BUILDING, Y. W. C. A., DENVER, COLO.

Many members of the YWCA were girls or young women who came to the "big city" looking for opportunities in employment and to escape the rigors of rural life. It was a stable refuge for many young women in a sometimes harsh, urban environment. The YMCA dormitory program ended in the mid-1970s. This building was sold in 1977 and subsequently torn down.

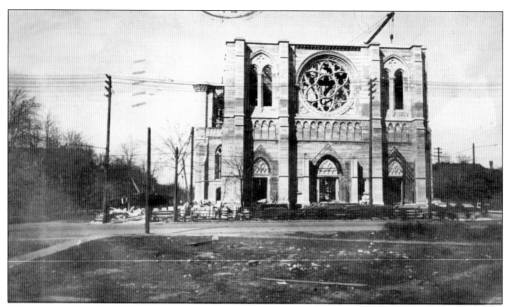

The crown jewel of Denver's Catholic community is the Cathedral of the Immaculate Conception, located at the corner of Colfax Avenue and Logan Street. A group of businessmen, including John F. Campion, Dennis Sheedy, J.K. Mullen, and James J. Brown paid for eight lots for the construction of the cathedral, and ground was broken in 1902. This rare postcard shows the cathedral during its first months of construction.

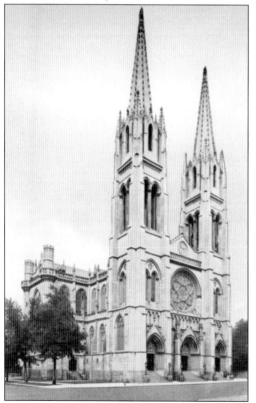

The cornerstone was laid in 1906, and the twin spires were capped in 1911. In 1912, one of the towers was struck by lightning, causing extensive damage. However, it was repaired in time for the dedication of the building that same year. In 1993, Pope John Paul II celebrated mass at the cathedral as part of World Youth Day. The cathedral continues to minister to those in need.

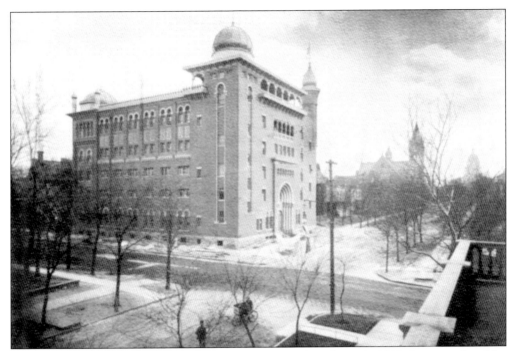

The Moorish-style El Jebel Shrine Temple was erected in the early 1900s but was closed by 1924 when the Shriners opted to move to West Fiftieth and Vrain Street. The huge auditorium, two-story ballroom, anterooms, and kitchens were used for storage for the next half-century. The temple's main floor lobby features oriental mirrors and a brass and stained-glass elevator.

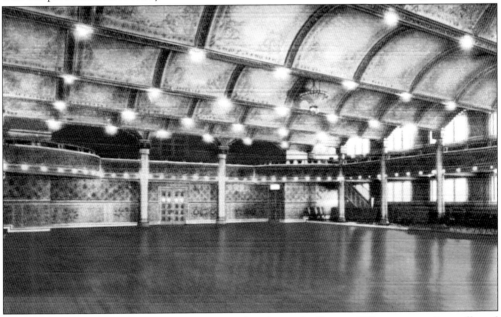

The Grand Ballroom remains just as it was when it was built over 100 years ago. Its scalloped ceiling and highly polished floors recall many of the ballrooms and dance halls across the country in the 1910s and 1920s. A wide balcony encircles the entire room. Now called the 1770 Sherman Street Event Center, it plays host to dances, weddings, proms, and catered events.

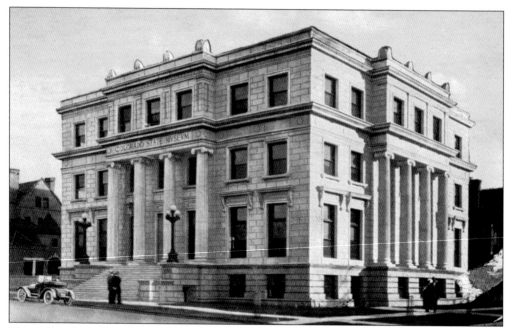

The Colorado Legislature created the Colorado State Historical Society in 1879. Its collection was originally housed in the Colorado State Capitol Building until its permanent home, the Colorado State Museum (pictured here), was erected at East Fourteenth Avenue and Sherman Street in 1912. It is faced with Colorado Yule marble.

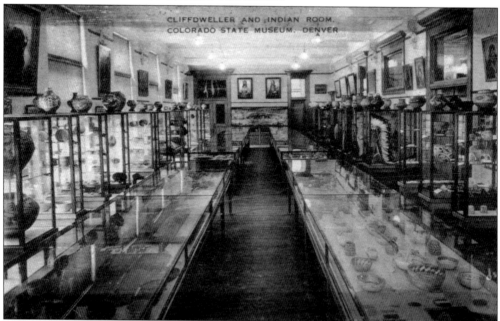

The Colorado State Museum is known for its outstanding displays regarding western culture, and its series of meticulous dioramas depicting activities of the Old West. The museum was moved to new quarters at 1300 Broadway in the mid-1970s. As this book goes to press, it is awaiting a move to a large, new building at Twelfth Avenue and Broadway. It is now known as History Colorado.

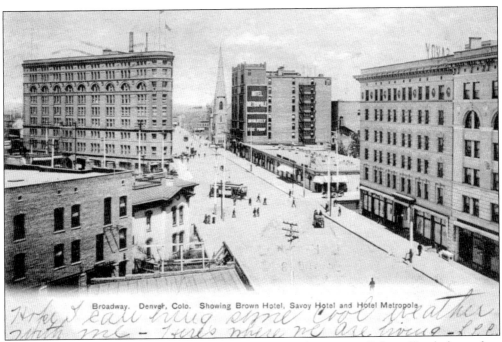

Broadway. Denver, Colo. Showing Brown Hotel, Savoy Hotel and Hotel Metropole.

Hope I can bring some cool weather with me — Here's where we are living — S.E.

This early view shows Broadway northbound, with the Brown Palace Hotel, located at Seventeenth Street, on the left, the Shirley-Savoy Hotel on the right, the Hotel Metropole in the center, and the spire of the Trinity United Methodist Church. Note the streetcar and horse and buggy.

Another view, this time looking south from approximately Nineteenth Street, shows the Trinity United Methodist Church (left), the Hotel Metropole (center), and the Brown Palace Hotel (right). The Metropole is gone, but the other two remain standing.

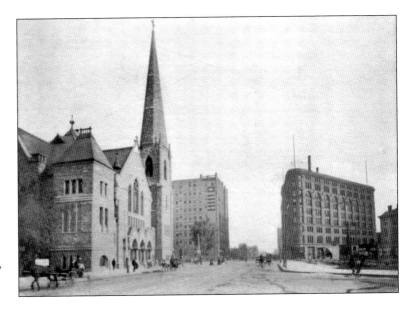

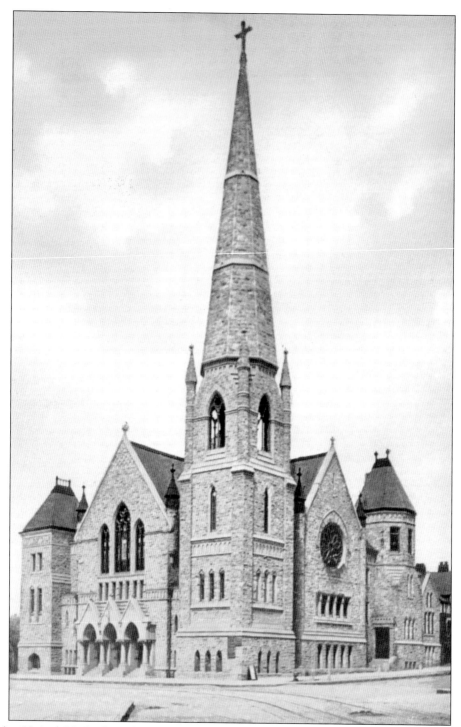

Trinity United Methodist Church, still standing at Eighteenth Avenue and Broadway, was designed by Robert Roeschlaub and constructed in 1887–1888. The church had various locations throughout downtown before settling here. After hitting hard times in the 1960s because of the neighborhood's transient character, the church again has a respectable membership.

Mary Baker Eddy founded the Church of Christ, Scientist and authored the basis of church beliefs, *Science and Health with Key to the Scriptures*. First Church of Christ, Scientist was built in 1901–1907 by architects Ernest Varian and Frederick Sterner and is located at 1401 Logan Street. The church still functions there. Famous Christian Scientists include Joan Crawford and Ginger Rogers.

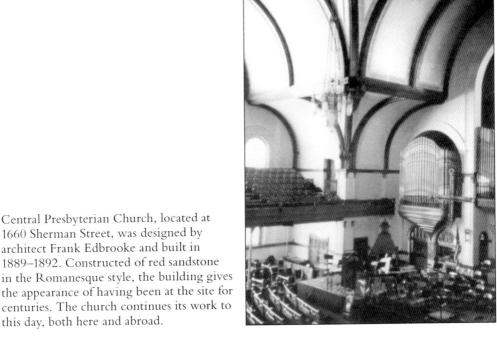

Central Presbyterian Church, located at 1660 Sherman Street, was designed by architect Frank Edbrooke and built in 1889–1892. Constructed of red sandstone in the Romanesque style, the building gives the appearance of having been at the site for centuries. The church continues its work to this day, both here and abroad.

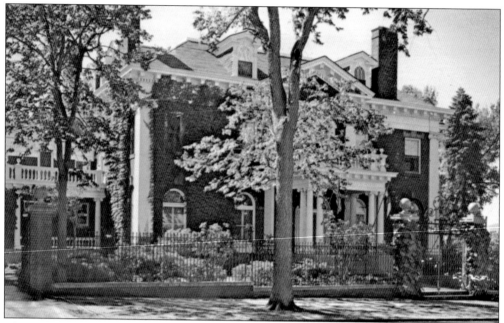

The Colorado Governor's Mansion, seen here, was built by Walter S. Cheesman's widow, Alice, in 1907. In 1923. it was sold to Claude K. Boettcher, son of Colorado industrialist Charles Boettcher. Claude and his wife, Edna, lived in the house until their deaths in the late 1950s. The house was then gifted to the State of Colorado for its Executive Mansion.

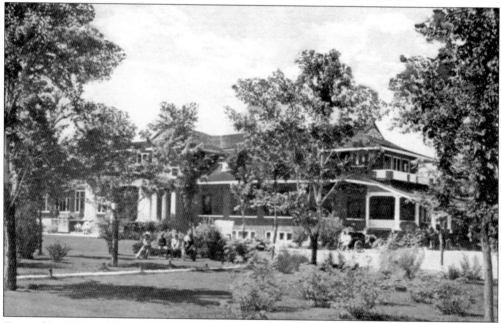

Opened in 1904 and founded by a group of prominent local businessmen, the Denver Country Club became a center of activity for the city's movers and shakers. It was built on over 200 acres of property once owned by John J. Reithmann, which is bounded roughly by University Boulevard, Downing Street, First Avenue, and Alameda Avenue. Among the amenities offered to its members are golf, swimming, tennis, and fine dining in its clubhouse.

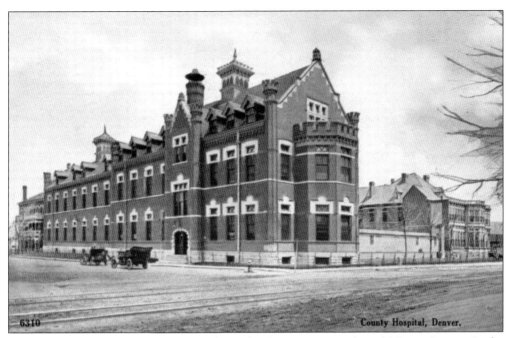

Denver's first city hospital opened in the early 1860s at Sixteenth and Wazee Streets. In the early 1870s, facilities moved to Sixth Avenue and Cherokee Street. After a series of expansions and rebuilding, most of the older buildings have been destroyed and Denver General Hospital is now a completely modern complex.

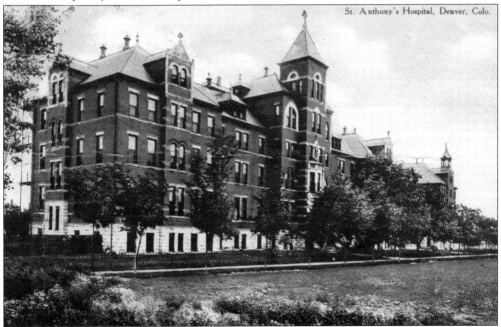

St. Anthony's Hospital was founded in the early 1890s by the Sisters of St. Francis Seraph at West Sixteenth Avenue and Quitman Street. The building shown was slowly replaced by new additions over the years. The hospital has recently vacated its buildings and moved to a new facility in Lakewood. The old site will be redeveloped.

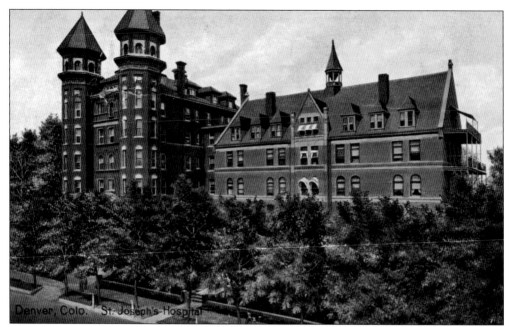

After operating from a number of different locations, including the St. James Hotel in the 1500 block of Curtis Street, St. Joseph Hospital settled into a new building at Eighteenth Avenue and Humboldt Street in the late 1870s. This twin-towered structure has been completely replaced by new twin-towered facilities.

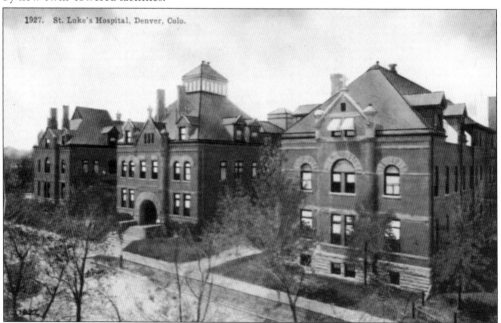

St. Luke's Hospital was founded by the Episcopal Church and offered its services at West Seventeenth Avenue and Federal Boulevard through the 1880s. In 1891, a new hospital was built at Nineteenth Avenue and Pearl Street in the Capitol Hill neighborhood. St. Luke's has merged with Presbyterian Hospital in that facility's complex at East Nineteenth Avenue and Franklin Street.

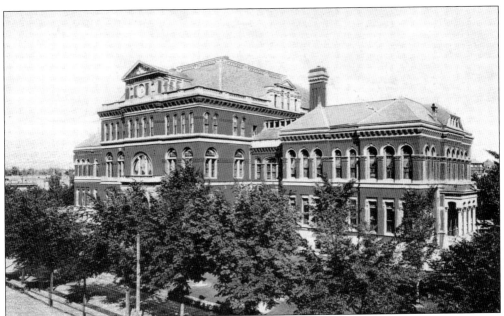

East Denver High School was designed by Robert Roeschlaub and erected in 1889 at Nineteenth and California Streets. By 1910, much of Denver's residents had moved away from downtown and a new East High School was built in 1924–1925 at Colfax Avenue and Detroit Street. The New Customs House, built in 1931, replaced the old high school building.

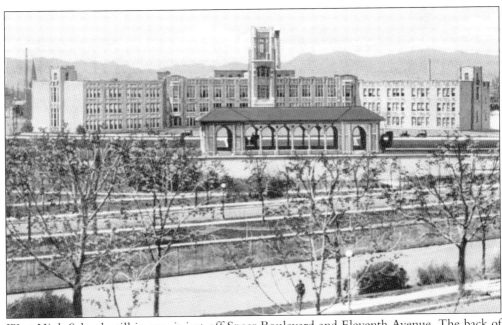

West High School, still in use, is just off Speer Boulevard and Eleventh Avenue. The back of this card states, "One of Denver's new school buildings, [it] is particularly distinguished by its wonderful setting beside Cherry Creek. The exquisite Sunken Gardens with its Pool and quaint Moorish Pavilion form the school's foreground." The gardens were removed and grassed over years ago.

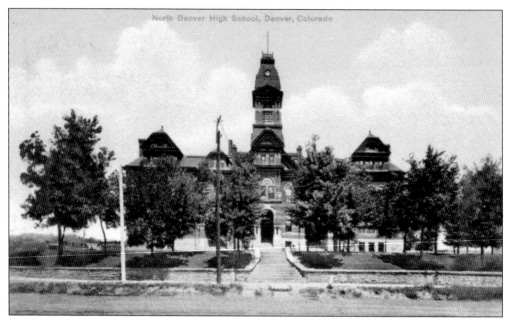

North High School traces its roots to a one-room schoolhouse downtown at Fifteenth and Central Streets. Ashland School, shown here, replaced another school building at West Twenty Ninth Avenue and Dunkeld Place in 1888. It eventually became North Side High School, but classes moved to a new building in 1911 at Speer Boulevard and Eliot Street, where it continues today.

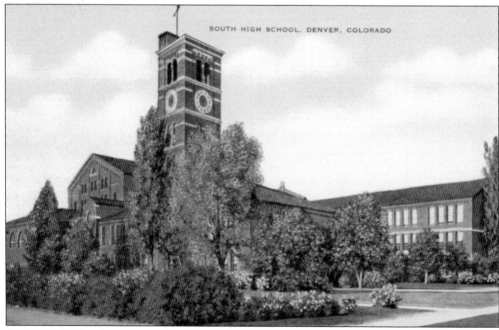

South High School was opened to students in January 1926 at 1700 East Louisiana Avenue after getting its start in the old Grant School building on South Pearl Street and Colorado Avenue. Built in a classic Romanesque style, this architectural gem remains one of the stellar institutions of learning in the south Denver area.

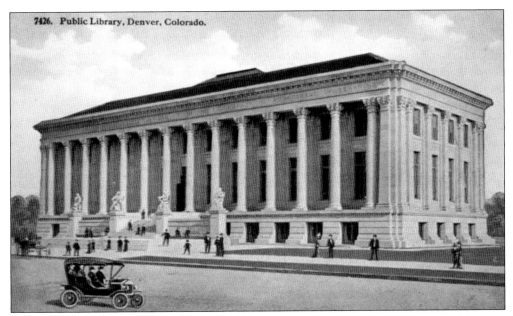

7426. Public Library, Denver, Colorado.

Denver's public library system is a result of the merger of a number of different entities over a period of years. The Denver Chamber of Commerce and old East High School collections formed a substantial basis of what was to come. Denver's library was temporarily housed in the old La Veta apartment building at the corner of West Colfax Avenue and Bannock Street. A new Carnegie Library, seen here, opened in 1910.

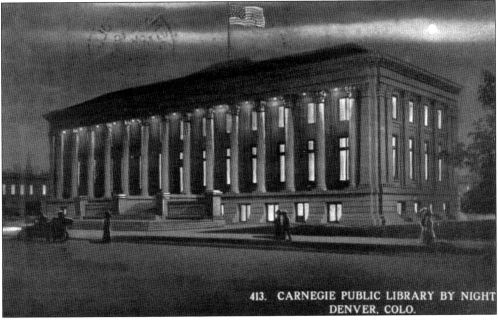

413. CARNEGIE PUBLIC LIBRARY BY NIGHT
DENVER, COLO.

In the early 1900s, steel magnate Andrew Carnegie was on a mission to build new libraries throughout the country, and Denver was fortunate enough to be on his list. His new library, seen here at night, replaced the La Veta facility. After the library was moved to a new building at Broadway and West Fourteenth Avenue in 1955, the old Carnegie building housed the Denver Water Department. It is now the McNichols Civic Center.

125

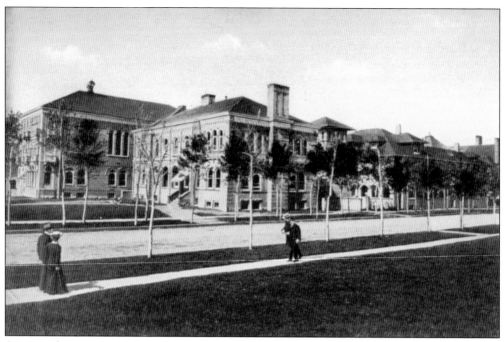

Anna Wolcott opened her Wolcott School for Girls in 1898 at 1410 Marion Street. It was the school for the daughters of Capitol Hill's wealthy citizens, and its alumni included Helen Brown, daughter of Margaret "Molly" Brown of *Titanic* fame, former first lady Mamie Eisenhower, and Clara Cody, granddaughter of William "Buffalo Bill" Cody. The building is now apartments.

The Capitol Life Insurance Company building, at 1600 Sherman Street, was designed by Harry Manning and built in 1924. Thomas Daly (1858–1921) had made his fortune in Leadville mining and founded Capitol Life in 1905. The original directors included Charles Boettcher, Frederick Bonfils, and John F. Campion. The building is now home to the Colorado Trust.

SOURCES

Cervi's Journal

Barnhouse, Mark. *Denver's Sixteenth Street*. Charleston, SC: Arcadia Publishing, 2010.

Jones, William C., and Kenton Forrest. *Denver, A Pictorial History*. Boulder, CO: Pruett Publishing Company, 1973.

Peters, Bette D., Louise Farrah, and Leland H. Peters. *Denver's City Park*. Boulder, CO: Johnson Publishing Company, 1986.

The Denver Post

The Denver Republican

The Denver Sun

The Rocky Mountain News

www.gsa.gov

www.city-data.com

DISCOVER THOUSANDS OF LOCAL HISTORY BOOKS FEATURING MILLIONS OF VINTAGE IMAGES

Arcadia Publishing, the leading local history publisher in the United States, is committed to making history accessible and meaningful through publishing books that celebrate and preserve the heritage of America's people and places.

Find more books like this at
www.arcadiapublishing.com

Search for your hometown history, your old stomping grounds, and even your favorite sports team.